DEVON AT WAR
THROUGH TIME
Henry Buckton

AMBERLEY PUBLISHING

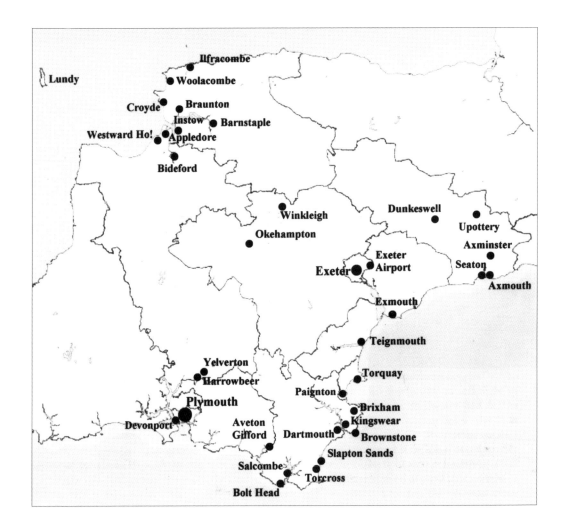

First published 2012

Amberley Publishing
The Hill, Stroud
Gloucestershire, GL5 4EP

www.amberley-books.com

Copyright © Henry Buckton, 2012

The right of Henry Buckton to be identified as the
Author of this work has been asserted in accordance
with the Copyrights, Designs and Patents Act 1988.

ISBN 978 1 4456 1000 9

British Library Cataloguing in Publication Data.
A catalogue record for this book is available from
the British Library.

Typeset in 9.5pt on 12pt Celeste.
Typesetting by Amberley Publishing.
Printed in the UK.

Introduction

During the Second World War Devon was reputedly the most militarised county in the country. This was particularly so just before D-Day when every town and village was bursting with American troops preparing to take part in the liberation of occupied Europe.

But the story of Devon at War begins long before that and in this book we shall be visiting places that were affected at different stages of the conflict. We learn how Plymouth and Exeter experienced some of the most devastating air attacks outside London, while even smaller communities along the South Coast suffered from the shock tactics of tip-and-run raids. We see the crucial part that the county's ports and harbours played in keeping Britain's Navy afloat and at the forefront of operations. And perhaps most important of all, we acknowledge the county's incalculable contribution to all aspects of Operation *Overlord*, on land, at sea, or in the air. Of course every community has its own story to tell but it would be impossible to include them all, so I hope the examples chosen will give a good summary of what took place in Devon as a whole.

We begin our journey in the south-west corner of the county at Plymouth, which, being one of Britain's main naval centres, was heavily involved from the onset. While much of the country read about events in their newspapers or heard about them on the wireless, the people of this provincial city were experiencing them at first hand.

Henry Buckton

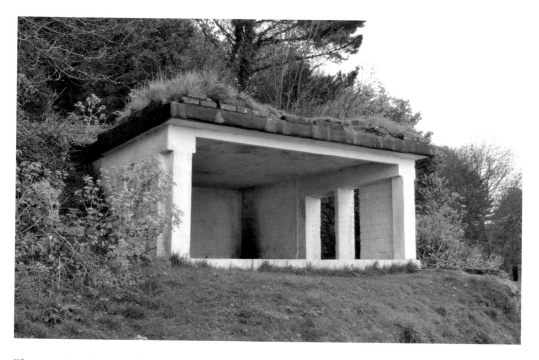

The remains of a searchlight emplacement at Brixham Battery.

Acknowledgements

Photo Credits

Author: top 15, 23, 29, 33, 48, 61, 65, 66, 70, 71, 77, 79, 82, 83, 93; bottom 3, 7, 8, 9, 12, 13, 14, 15, 16, 17, 20, 23, 25, 26, 27, 28, 29, 30, 31, 32, 33, 36, 39, 41, 45, 47, 48, 53, 54, 55, 56, 57, 59, 60, 61, 62, 63, 64, 65, 66, 67, 69, 70, 71, 73, 75, 77, 78, 79, 80, 81, 82, 83, 84, 85, 86, 87, 88, 89, 90, 91, 92, 93, 94, 95, 96. Author's collection: top 7, 8, 12, 27, 28, 30, 38, 53, 56, 58, 59, 68, 76, 81, 86, 90, 94; bottom 5, 18, 58, 72. Aveton Gifford Parish Project Group (Delia Elliott): top 75. Anthony Basterfield: top 52. Copyright Ben Brooksbank and licensed for reuse under the Creative Commons License: top 60. Bundesarchiv: top 45, 46, 54. Paul Chryst: top 72. Gerry Cullum: top 19; bottom 19. John Douglas: bottom 52. Dunkeswell Memorial Museum: top 67. John Fletcher: top 73. Peter Garwood, Balloon Barrage Reunion Club: top 44. Roger Geach: bottom 10, 11. Copyright Mac Hawkins and licensed for reuse under the Creative Commons License: top 63, 64. Alan Heather, Torquay Museum: top 78, 80. Tim Hollinger, airborne506.org: top 96; bottom 49. Frank Kidwell: top 57. Sheila Pitman: top 22, 50, 51; bottom 51. Copyright RuthAS and licensed for reuse under the Creative Commons License: top 43. George Trussell: top 42. Brian Turnham: top 49; bottom 42, 43, 46, 50. Katy Waters: bottom 68. The Wilson Archive: top 74; bottom 74. The 4th Division Living History Group: top 55; bottom 22. The 225th Anti-Aircraft Artillery Searchlight Battalion (US Army): top 24, 25, 26, 62; bottom 24. Michael Virtue, Virtue Books: top 5, 6, 9, 10, 11, 13, 14, 16, 17, 18, 20, 21, 31, 32, 47, 69, 84, 85, 87, 88, 89, 91, 92, 95; bottom 6, 21, 44, 76. Reproduced from *Exeter Phoenix: A Plan for Rebuilding* by Thomas Sharp, published for the Exeter City Council by the Architectural Press (1946): top 34, 35, 36, 37, 39, 40, 41; bottom 34, 35, 37, 38, 40.

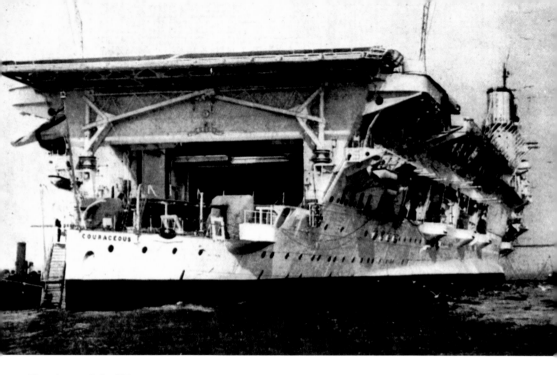

First Loss of the War

On the very evening that war was declared, the mighty aircraft carrier HMS *Courageous* (above) slipped out of Devonport bound for the Western Approaches, where the Fairey Swordfish aeroplanes on her deck would begin hunting for German submarines. Fourteen days later, on 17 September, she was sunk by U-boat *U-29* with the loss of over 500 crewmen, including the captain, William Makeig-Jones, last seen standing on the bridge. *Courageous* was the first British warship to be lost during hostilities and most of those who died were based at the Royal Naval Barracks at Keyham in Devonport (below).

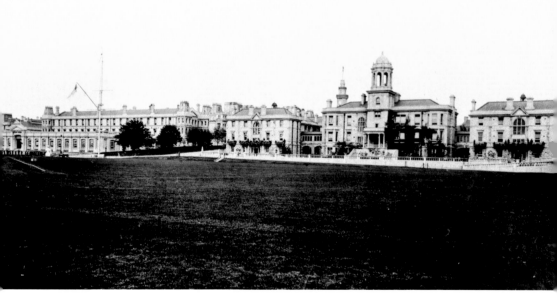

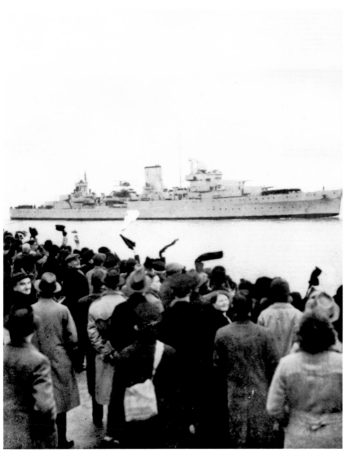

Returning to Devonport

There were also moments of early jubilation, such as the arrival of HMS *Ajax* for repairs in January 1940. She had taken part in the Navy's first victory of the war, the Battle of the River Plate, during which the German pocket battleship *Admiral Graf Spee* had been scuttled. Cheering crowds gathered along the seafront as *Ajax* was towed into her berth. Two weeks later the Devonport-built and manned cruiser HMS *Exeter* also returned to a hero's welcome. The photograph above shows HMS *Ajax* sailing through Plymouth Sound, while below, HMS *Exeter* is seen returning safely to Devonport.

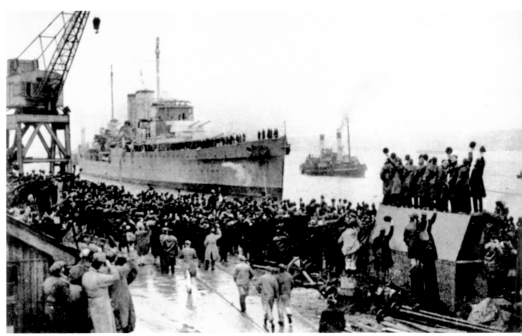

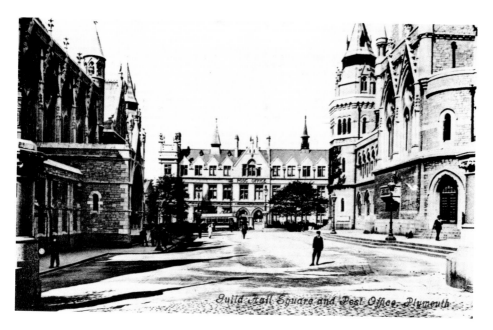

Guild Hall Square and Post Office, Plymouth

Thanks of the Nation

Having also taken part in the Battle of the River Plate, HMS *Exeter* had undergone repairs in the Falkland Islands before attempting the passage home. Winston Churchill, who at that time was the First Sea Lord, was among her welcoming party. Churchill thanked the ship's company on behalf of the nation from aboard her gun deck. Sixty had failed to return, and the next day survivors of the battle marched through the streets of Plymouth to a reception at the Guildhall, pictured above on the left of the pre-war postcard, while below we see what remains of the Guildhall today.

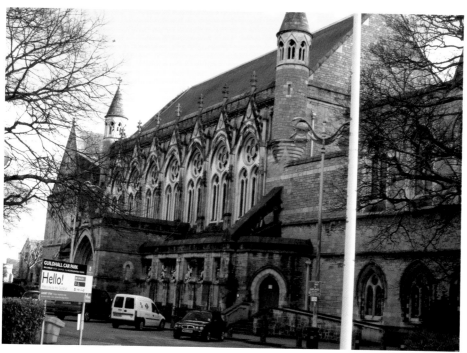

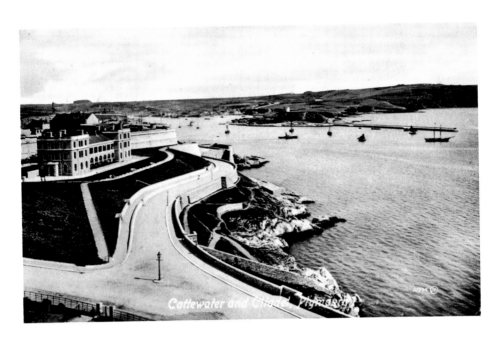

Cattewater and Citadel Plymouth

Operation *Ariel*

Following the evacuation of Dunkirk, many of Plymouth's naval and military establishments, including the Citadel fortress on the Hoe (pictured above in an old postcard and below today) were used as staging camps by French troops, who arrived in the city by train through Turnchapel Station and a short while later embarked again from Millbay Dock bound for their final destinations. Their billets were quickly filled by British troops evacuated during the lesser-known Operation *Ariel*, two weeks after Dunkirk. This was the codename for the extraction of Allied personnel from the most westerly ports of France.

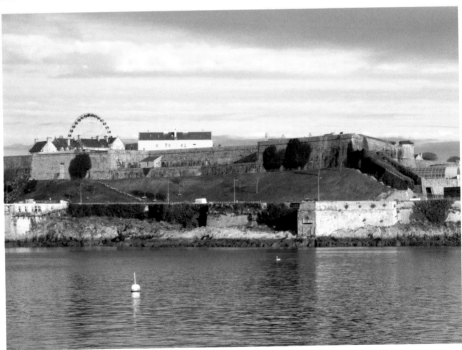

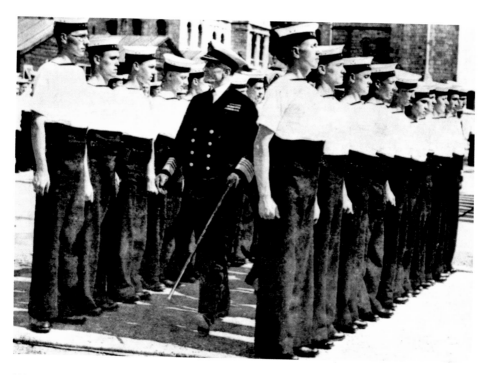

Worst Maritime Disaster

Operation *Ariel* was directed by Admiral Sir Martin Nasmith, pictured above inspecting seamen in Devonport. However, the evacuation from St Nazaire was blighted by the worst disaster in British Maritime history, when the Cunard passenger ship *Lancastria* was attacked and sunk by Junkers Ju 88s, with an estimated loss of 4,000 lives. The survivors were rescued from the sea by other craft and landed at Plymouth for transferral to the Royal Navy Hospital. Operation *Ariel* accounted for the evacuation of over 190,000 Allied troops. Below we can see some of the buildings that were once part of the RN Hospital.

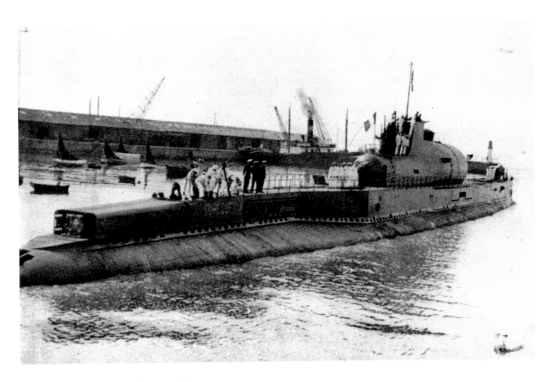

Largest Submarine in the World

In June 1940 the French signed an armistice with the Nazis, by which time a number of their warships were anchored safely at Devonport, including the *Surcouf*, then the largest submarine in the world. This posed a problem when Winston Churchill, who was now Prime Minister, issued the French Navy an ultimatum to surrender its ships or face the consequences. He was fearful that Admiral Darlan, the commander of the French fleet, would collaborate with Hitler. Above we see the *Surcouf* and below the Devonport Dockyard frigate refit complex today.

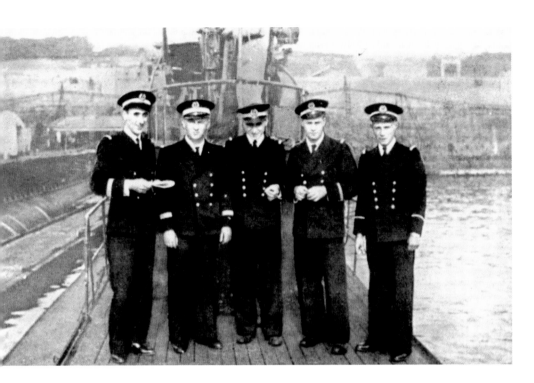

Attack on French Ships

Admiral Darlan refused to co-operate with Churchill, so the Prime Minister ordered an attack on French ships at the port of Oran in Algeria, which resulted in the deaths of 1,297 French sailors. The day before the attack, French crews off the coast of Devon were instructed to moor their boats alongside jetties in Devonport, as shown above. This was a ruse in order for them to be boarded by a British task force. The French tried to resist, but in the ensuing firefight one French and three British sailors were killed before their vessels were finally secured. Below, modern warships are seen in Devonport's Weston Mill.

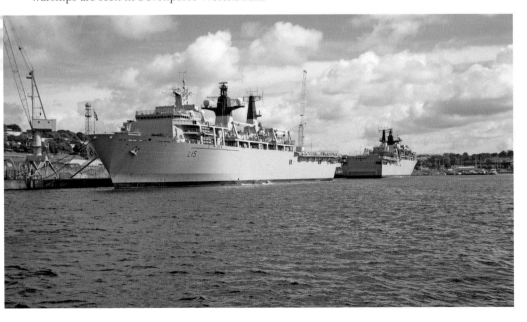

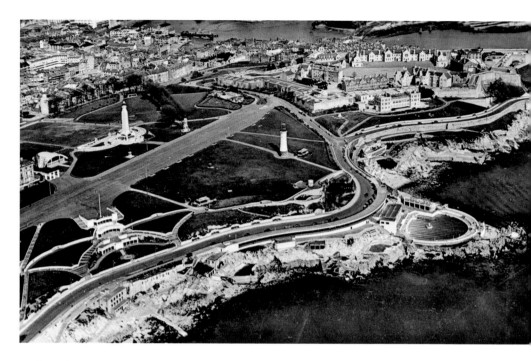

Sealing the Port

Although an assault on Plymouth from the sea was considered a possibility, it was thought to be too far away from Germany to be subjected to aerial attack. However, with the capitulation of France this situation changed, as the Nazis could now launch raids from just across the Channel. The first indication of the Luftwaffe's ability to reach the city came in the shape of Junkers Ju 88s dropping mines into Plymouth Sound to seal off the port. Above we see a pre-war aerial view of Plymouth Hoe as the Luftwaffe pilots would have seen it, and below as it appears today.

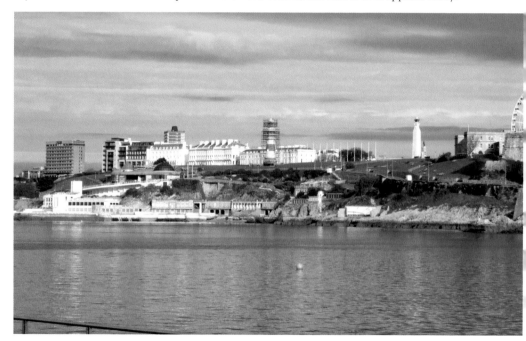

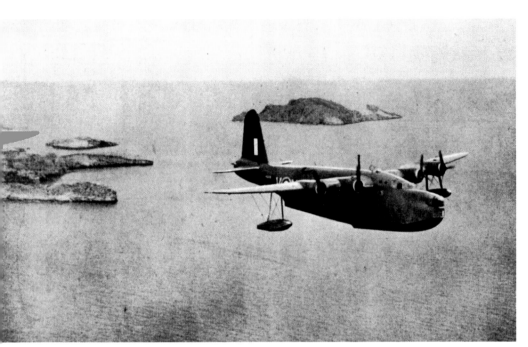

Air Defence of Plymouth

Although there were anti-aircraft guns and barrage balloons around Plymouth, there were very few fighter aircraft. Gloucester Gladiator biplanes of No. 247 Squadron were based at RAF Roborough, later the site of Plymouth Airport, but these would prove hopelessly inadequate. Later in the war they were replaced by other units flying a variety of aircraft. There were also Sunderland flying boats at RAF Mount Batten, used by RAF Coastal Command. Above we can see a Sunderland in flight, and below a monument depicting one of these aircraft, which can now be found at the site of the former airfield.

13

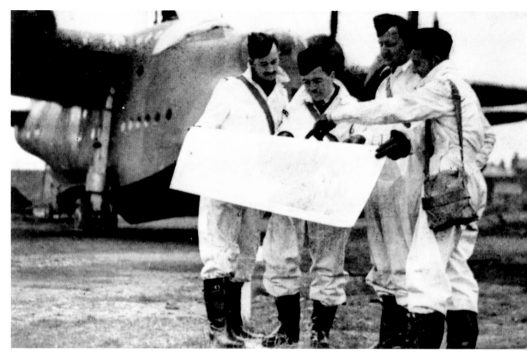

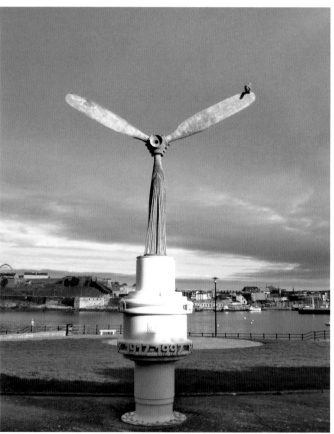

Looking for Submarines
The Sunderlands at RAF
Mount Batten were used
by Coastal Command for
anti-submarine patrols,
and would be employed to
search for enemy U-boats
operating in the Channel
or even attempting to enter
the docks at Devonport
and attack the Navy's
vessels there. Nos 10 and
461 Squadrons of the
Royal Australian Air Force
were very successful in
this task. Above we see an
Australian crew standing
in front of one of their
aircraft. Today there are
very few visible reminders
of the former airfield other
than two of the original
hangars. The memorial
seen left in the shape
of a propeller now also
indicates the location.

Dealing with the Threat

The need for effective air and coastal defence to deal with the threat of enemy attacks saw the area of Mount Batten also given over to numerous defence structures. These include the remains of two light anti-aircraft gun emplacements and a signal identification panel on the area of the plateau near the artillery tower, the bases of which can be seen in the photograph above. There were also two L-shaped anti-submarine searchlight batteries of brick and shuttered concrete construction, one of which we can see in the picture below. These remain intact minus their searchlights.

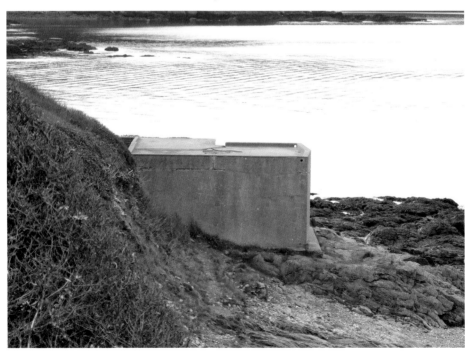

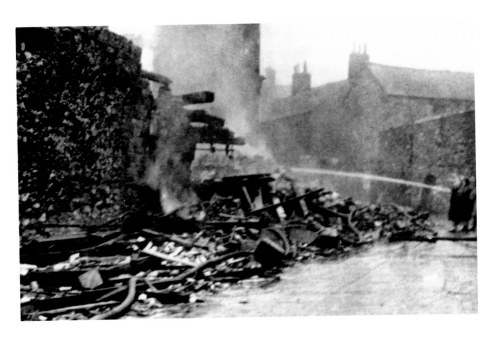

First Bombs

The first attack on the city itself happened on 6 July 1940 when bombs were dropped on the Corporation housing estate in Swilly Road, Devonport, killing three people (above). On 27 November, RAF Mount Batten was among the targets when one of the hangars was set alight and a Sunderland destroyed. A huge oil tank in the Admiralty's fuel depot adjacent to Turnchapel railway station was also hit, causing a fire that spread from tank to tank, and which eventually spilled burning oil into Hooe Lake (seen below today from Barton Road) creating a cloud of smoke that hung over the city for five days.

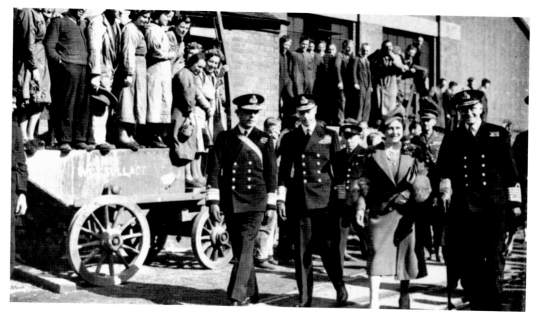

Plymouth Blitz

The worst raids, now referred to as the Plymouth Blitz, occurred over seven nights in 1941. The first, on 20 March, began with a visit from the king and queen, who toured naval establishments and ship-building yards (above), before taking tea with Lady Astor at her house in Elliot Terrace (below). The royal train departed at 5.45 p.m. That evening, shortly after 8.30 p.m., more than 100 German aircraft pounded the city. Tragedies were too numerous to list but probably the worst incident was a direct hit on the hospital at Greenbanks, which left three nurses and fourteen babies dead.

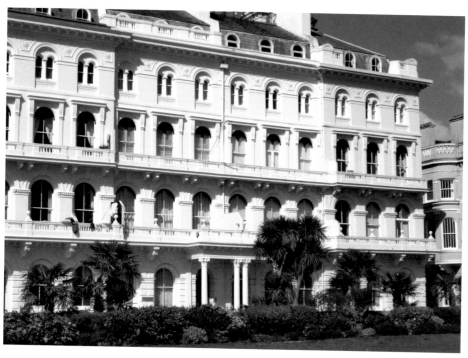

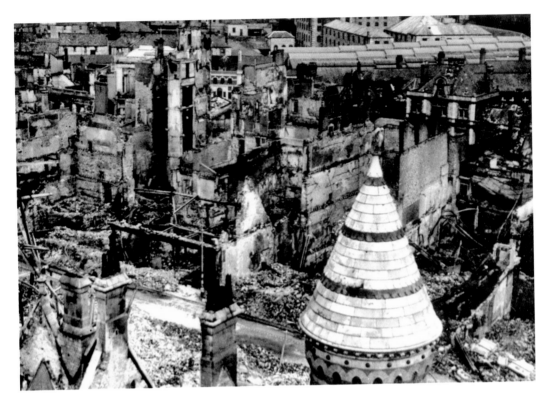

Destruction of the City Centre

The following night the bombers returned at around 8.50 p.m. and before long fires raged over a wide area, from Coxside in the east to the Royal Naval Barracks at Keyham in the west. The city centre was devastated, as seen above, and by the end of the night it was claimed that only two buildings survived: the Westminster Bank in Bedford Street and the offices of the *Western Morning News* in Frankfort Street. All administrative centres such as the Guildhall and Municipal Offices were totally gutted. Below is a pre-war view of Bedford Street.

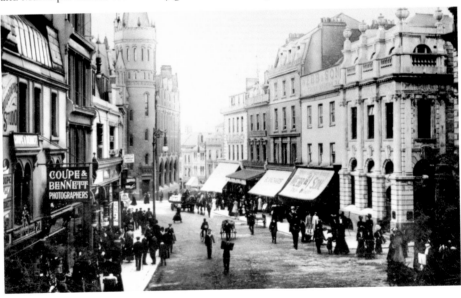

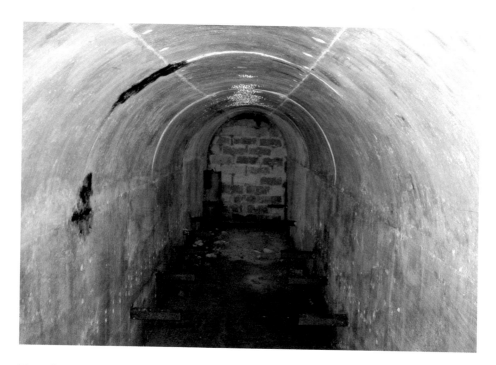

Tragedy at Portland Square

Things were relatively quiet for the next month, until on 21 April the bombers reappeared. This time Devonport and the naval docks were the principal targets, although much of the city was also affected. In Portland Square, now part of the site of Plymouth University, an underground shelter took a direct hit, killing seventy-two people. The domed building in the picture below stands over the location; while the photograph above shows the remains of the middle-east tunnel of the shelter. At HMS *Drake*, the naval shore establishment, an accommodation block was hit from which seventy-eight bodies were recovered.

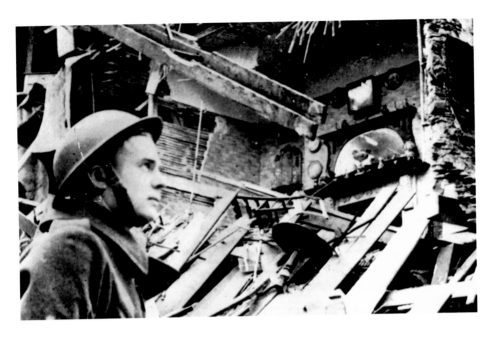

End of the Blitz

Raids continued over the next two nights but with the city centre in tatters, they targeted rows of terraced housing, as seen in the picture above. The final nights of the Plymouth Blitz were 28 and 29 April. The total of those who died in all seven raids was 826, many of whom are buried in the communal grave at Efford Cemetery (below). Around 40,000 people known as 'trekkers' would flee the city each night to sleep at rest centres in places such as Plympton and Ivybridge. Others headed for Dartmoor to camp in the open. Children were evacuated to safer havens in other parts of Devon or Cornwall.

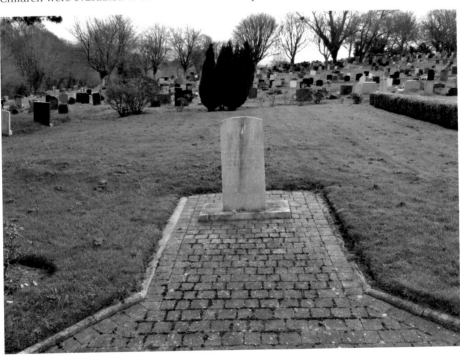

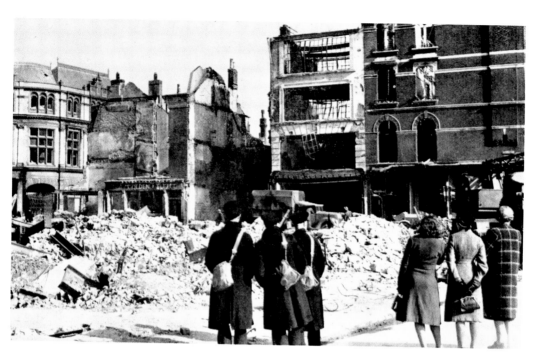

The Bombing Goes On

On 2 May, Winston Churchill visited the city to review the damage. He visited the docks and inspected warships before touring the streets. Although the Plymouth Blitz was over, the city would still be bombed from time to time; the last occasion being 30 April 1944, when the main target was the waterfront. At Oreston, eighteen people were killed in air-raid shelters. Also hit was the depot of the Western National Omnibus Company at Prince Rock where three fire watchers were killed and many buses destroyed. The photograph above shows the result of one raid, while below, residents of Plymouth salvage their possessions.

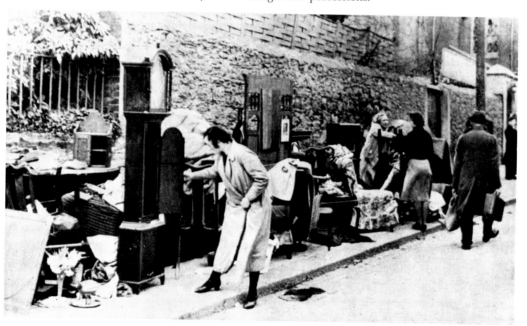

Arrival of the Americans in Devon

When the United States entered the war in December 1941, it was on Plymouth that much of its naval preparations for D-Day would be focused. As plans for the re-conquest of occupied Europe began to unfold, the whole of Devon was largely given over for the training and housing of American troops, mainly of the 4th and 29th Infantry Divisions, as well as providing them with launching sites for the initial phase of Operation *Overlord*. Above, GIs are pictured at the American hospital in Axminster, while below, the 4th Division Living History Group display uniforms and equipment of the period.

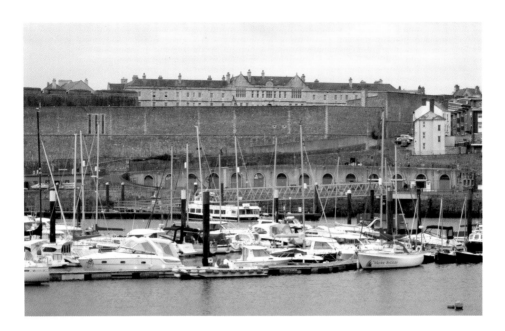

Housing the Troops

On Monday 8 November 1943 the United States Naval Advanced Amphibious Base was set up, taking over much of Plymouth's maritime infrastructure. Their headquarters were at Queen Anne's Battery, pictured above today, where the 29th and 81st US Construction Battalions built a ship repair yard for the maintenance of US naval craft. Personnel were quartered across the city using establishments such as Raglan Barracks, the derelict gatehouse of which can be seen below, or they built their own, including a large camp in Vicarage Road, which housed troops waiting to take part in the D-Day landings.

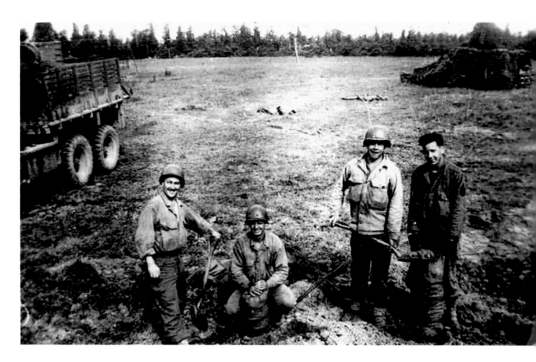

Training on Dartmoor

Before the invasion, both the 4th and 29th Infantry Divisions trained intensively on Dartmoor (above). Thousands of troops were billeted in tented camps (below) alongside the roads that crossed the moors, while the tors reverberated constantly to the sound of battle. Some shells were even fired by the Navy from Plymouth Sound. Heavy tracked artillery pieces were said to have been driven to Folly Gate, north of Okehampton, from where their guns fired shells over the town onto the moor. Then, just as quickly as they arrived, the Americans moved out to be loaded on the landing craft destined for Normandy.

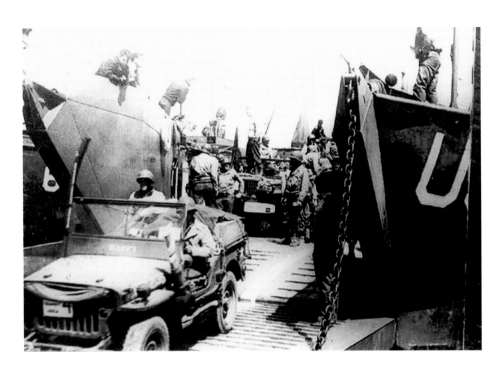

Plymouth's Part in D-Day

On the evening of Monday 5 June 1944 some 36,000 troops left Plymouth, bound for Normandy (above). First to leave were 110 ships carrying men of the United States VII Corps, who were part of the 4th Infantry Division. Before the invasion their ships had made use of every part of Plymouth's waterfront, from Millbay Dock (below) to Plymouth Sound. After sailing into the Channel they joined up with further vessels leaving from Salcombe, Dartmouth and Brixham. This force then headed towards the coast of France, where they were among the first troops to land on Utah Beach.

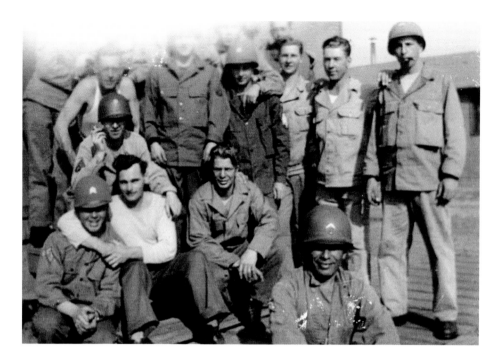

Embarkation of Troops

On a piece of green just off Barton Road in Turnchapel, facing out towards Hooe Lake, you will find the monument pictured below. The inscription reads, 'This memorial is dedicated to the embarkation of the United States Army 29th Division from Turnchapel to spearhead the Normandy Landings on D-Day, 6 June 1944.' In 1943 Barton Road was reinforced by the US Construction Battalions to carry tanks and personnel to be loaded on to LSTs (Landing Ship Tanks) from concrete platforms laid down at Sycamore Beach. Above we see American troops relaxing before the invasion; their smiles hide the anxiety they must have felt.

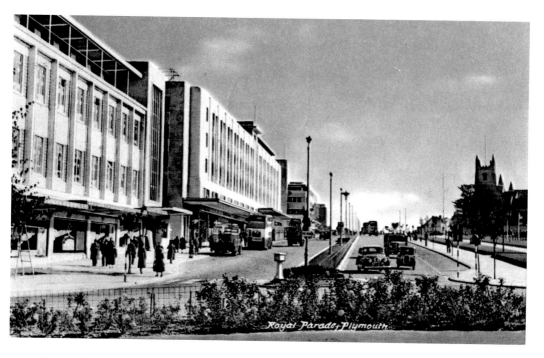

Plymouth Remembers

The people of Plymouth experienced many different aspects of the war, and it would take years of rebuilding their homes and services before it would eventually be transformed from bomb-sites into one of the most vibrant cities in the South West, as illustrated in the postcard above from the 1950s. There were fifty-nine bombing raids on the city during the conflict, which left 1,172 civilians dead, as well as many service personnel. Below we can see the Blitz Memorial, which can be found in Efford Cemetery, where it looks solemnly out across the rooftops of the modern city.

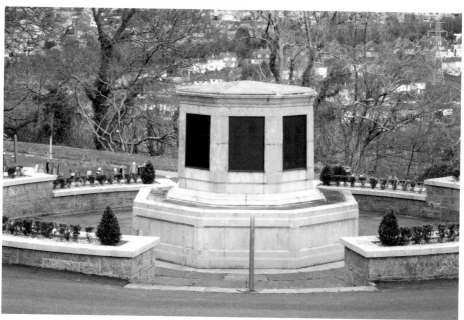

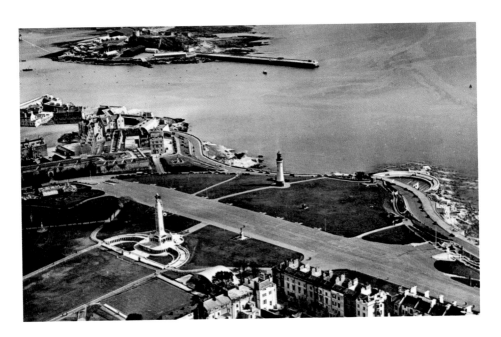

Plymouth Naval Memorial

On Plymouth Hoe you will find the city's Naval Memorial, seen below as it appears today and above in an old postcard, where its obelisk towers towards the bottom-left of the picture. The memorial was built to commemorate sailors who died and were buried at sea, therefore having no known grave. From the Second World War 15,933 individuals are listed. This postcard is also interesting because in its top-left corner you can see the buildings of RAF Mount Batten. Nissen huts and other structures are clearly visible, most of which were cleared after the station finally closed in 1992.

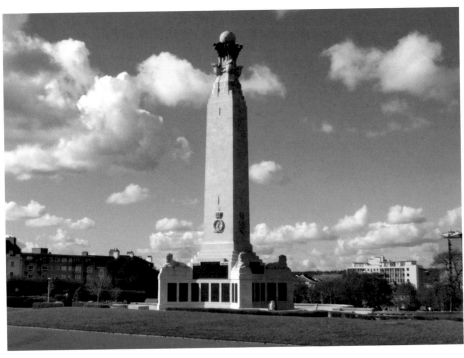

Poignant Reminder

There are several more monuments around the city, which include the RAF memorial (above) also on the Hoe. This is a tribute to the men and women who served in all commands of the RAF, Commonwealth and Allied air forces during the Second World War. But perhaps the most poignant reminder of how the city was affected by the struggle are the remains of Charles Church (below). During the nights of 21 and 22 March 1941 the building was entirely burned out by incendiary bombs. It is now dedicated as a memorial to all of those who were killed in air raids on the city.

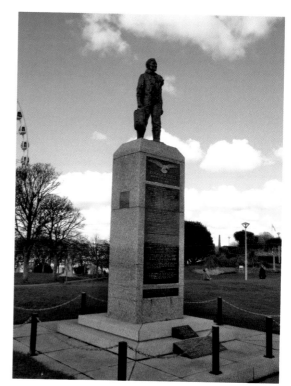

RAF Harrowbeer

Travelling north through Dartmoor you arrive at the site of the wartime airfield of RAF Harrowbeer near Yelverton (above), which was opened in the summer of 1941 as a component station within No. 10 Group Fighter Command. However, it became operational too late to help protect Plymouth during the Blitz and was in fact largely built using rubble that had been salvaged from the bombed city. Unusually, some of the shops and houses along Princetown Road were reduced to one storey as they posed a problem for aircraft coming in to land, as illustrated in the scene below.

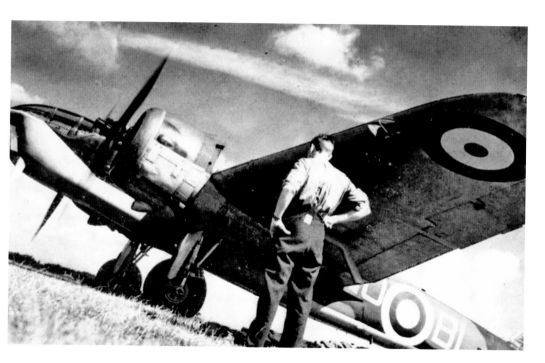

The Watch Office

Initially some of the properties within Yelverton itself were commandeered for RAF use, such as Knightstone (below), which is now a restaurant and tea room. This was used as the original watch office, until a new one and other buildings were completed at the airfield. Although it was built as a fighter station, aircraft from Harrowbeer were employed in various duties. The first operational unit was No. 500 Squadron, flying Bristol Blenheims adapted for the fighter role (above), while No. 276 Squadron on the other hand were involved in air-sea rescue duties and flew Lysanders.

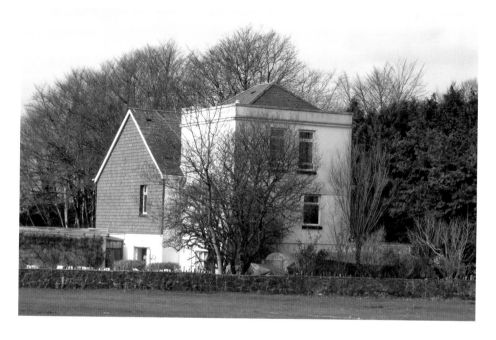

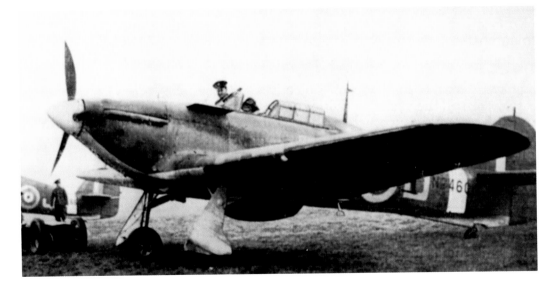

Varied Roles

Czech, Canadian, French and Polish squadrons (above) all flew from Harrowbeer, their main duties being the air defence of Plymouth, to provide escorts for convoys sailing through the Channel and to provide fighter cover for bombing runs over France. Before D-Day, British and American crews flew aircraft such as Spitfire Mk XIVs, or rocket-firing Typhoons to attack enemy radar sites and shipping. Very little remains of the station today but a memorial in Yelverton (below) is dedicated to the pilots of the many Commonwealth and Allied countries who operated from this remote moorland spot, along with their ground crews and airfield defence units.

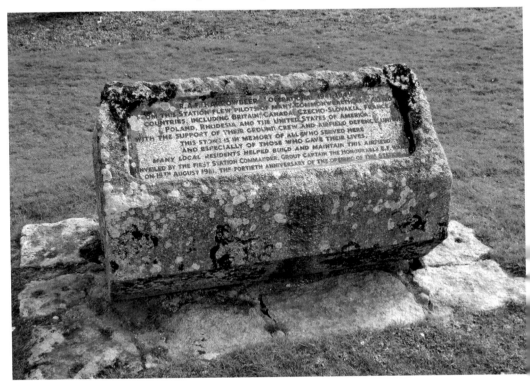

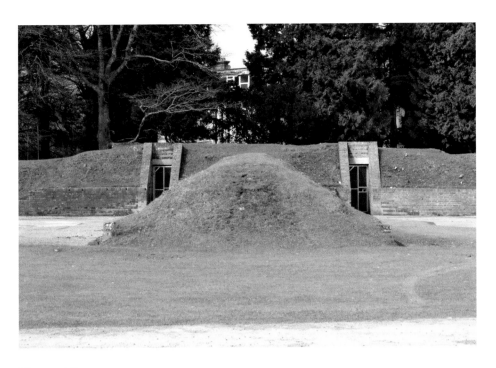

Dispersal Pens

Among the remains at Harrowbeer are the concrete bases of various buildings (below) and eleven blast bay/dispersal pens. These are found around the perimeter of the airfield and were built in the shape of three fingers. Aircraft would be awarded a certain amount of protection here in the event of an enemy attack. Each set of pens also had an air-raid shelter where the men working on the aircraft could escape from attack or keep dry during inclement weather. The ones seen above have now been cleared of rubble and restored by the RAF Harrowbeer Interest Group.

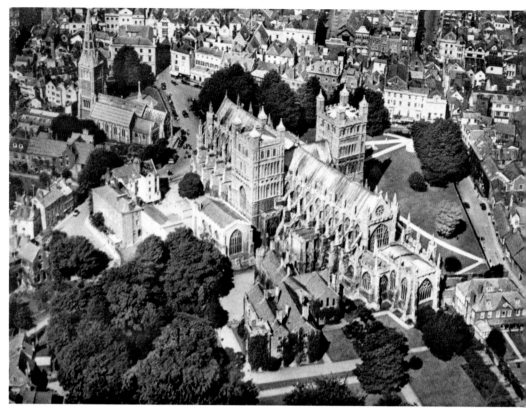

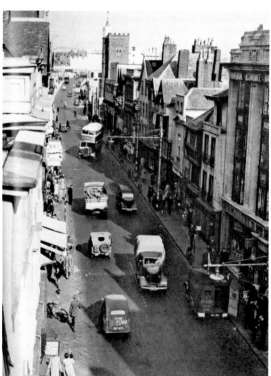

Target Exeter

After Plymouth, the place that suffered worst from enemy bombing in the county of Devon was its capital city, Exeter, seen above and below in pre-war photographs. Between August 1940 and May 1942, Exeter suffered a total of nineteen air-raids that caused damage. The first of these was perpetrated by a single aircraft on the night of 7 August 1940, when five high-explosive bombs were dropped on St Thomas. The first fatalities are believed to have been in a raid on 17 September 1940 when a house on Blackboy Road was destroyed, killing four boys.

Baedeker Raids

In most early raids the city was not the intended target and the bombs were leftovers jettisoned from aircraft returning from attacks on the industrial north. That would all change in April 1942, when Exeter was the first target in a series of raids that became known as the Baedeker Blitz, said to be in reprisal for the RAF's bombing of the beautiful cities of Lübeck and Rostock. Targets were selected from a tourist guide to Great Britain for their architectural and cultural significance. Also targeted were Bath, Norwich, Canterbury and York. These pictures show the aftermath of the Exeter raids.

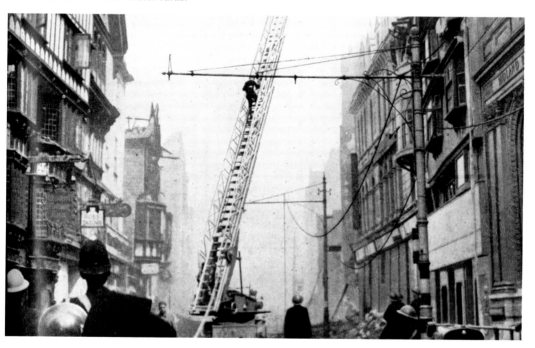

Opening Raid

The first raid on 23 April 1942 was not a huge success, although the Luftwaffe did cause considerable damage in the Okehampton Street area of St Thomas and killed five people. The following night they tried another tactic and encircled the city with parachute flares, dropping their loads within the circle. As a consequence sixty-five high-explosive bombs were dropped, killing seventy-three people, mostly in the area of Pennsylvania (above). A further raid on 26 April saw the release of one high-explosive bomb and large numbers of incendiaries, causing extensive damage in Portland Street (below today).

Most Devastating Attack

Although these attacks had brought death to the city, they had not caused the destruction that the Luftwaffe intended. So in the early hours of 4 May, a large force of bombers navigated up the River Exe (above). Their mission was to completely destroy the heart of the city. Flying low, they unleashed around 10,000 incendiary bombs and 75 tons of high-explosives. Amazingly, Exeter had no barrage balloons, which meant that the raiders could drop to heights at which the city's anti-aircraft guns were ineffective. The result was devastating and soon large parts of the city were ablaze (below).

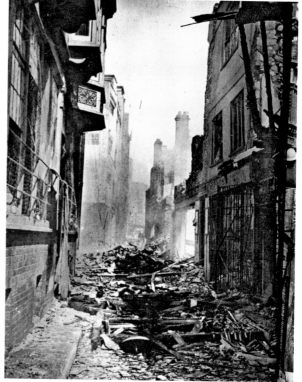

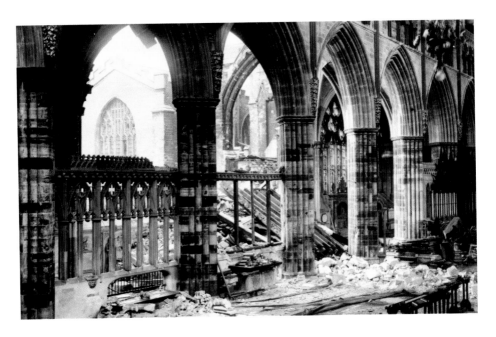

A City in Ruins

Extensive damage was done to both the central shopping and business areas of the city, along with residential and industrial premises. The recently built city library, which housed the Civil Defence control centre in its basement, was destroyed. Also hit was the cathedral, where a bomb demolished three bays of the south choir aisle (above). Bedford Circus, pictured below before the war, which at the time was considered to be one of the finest examples of eighteenth-century urban architecture in Britain, was completely razed to the ground. Southernhay was among other areas to be very badly affected.

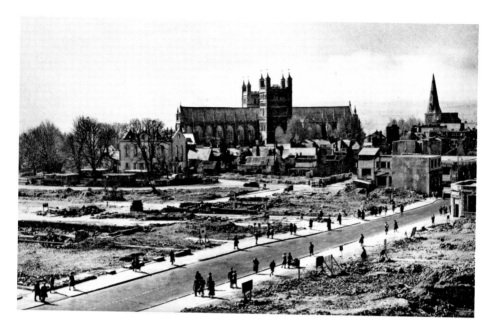

Worst Night of the War

This was without doubt Exeter's worst night of the war. The following announcement was made on German radio: 'We have chosen as targets the most beautiful places in England. Exeter was a jewel. We have destroyed it.' The photograph above gives some idea of the scale of the devastation. The total of those killed during all air-raids on Exeter was 265, many of whom lie buried at Higher Cemetery (below). Five days after the attack the king and queen visited the city during a tour of the West Country, stopping on their route to inspect the bomb damage to the cathedral.

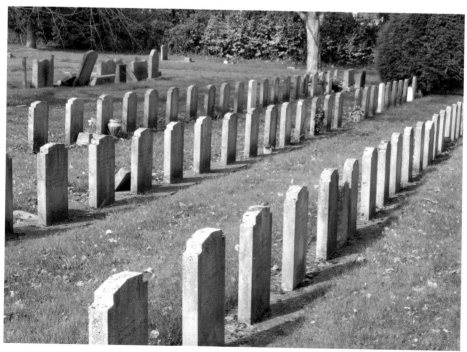

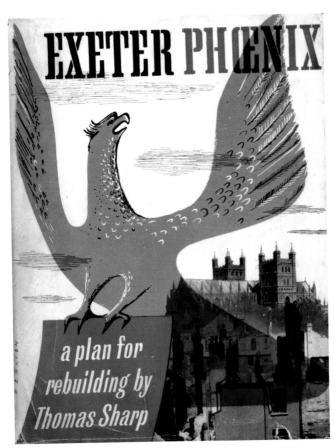

Redeveloping the City

The end of the war brought the task of rebuilding the city's commercial centre, and by 1945 most of the ruined buildings had been cleared. Thomas Sharp, a professional town planner, was asked to produce plans for the redevelopment of the city which, when completed, were displayed to the public in the burnt-out shell of the city library. However, due to financial restraints only a small part of his plans was ever realised. Above is pictured the cover of his 1946 publication *Exeter Phoenix*, which illustrated his plans, and below we see an example of one of his technical drawings.

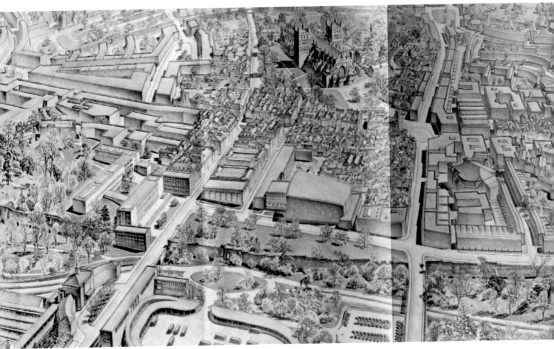

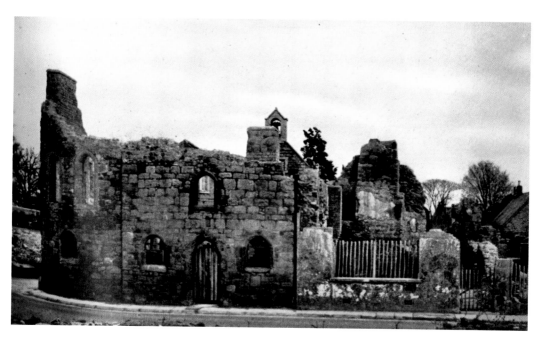

A Modern City

Today Exeter is very different from the pre-war city, and its main shopping centre is one of the liveliest in the country. The remains of the fifteenth-century St Catherine's Chapel and almshouses are now preserved as a memorial to the Blitz, as they were destroyed during the bombing. They bear witness that to a certain degree the Baedeker raids on Exeter were successful in their attempt at destroying the heritage of Devon's beautiful capital city. The above study was taken just after the war, while below we see the ruins today.

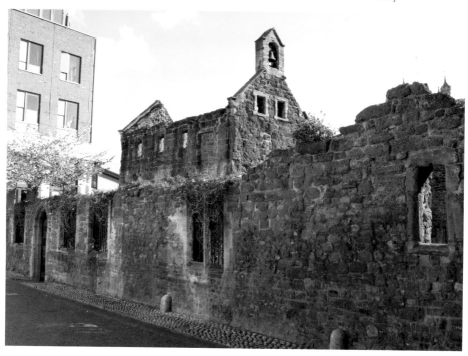

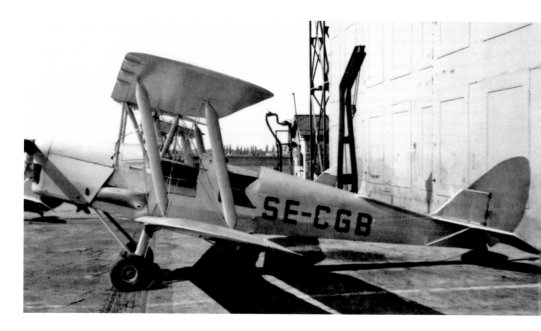

RAF Exeter

About 3 miles to the east of Exeter you will now find Exeter International Airport (below), which during the Battle of Britain was the site of Devon's principal RAF fighter base. An airport was first opened here in 1937, running regular air services to the Channel Islands and other destinations in the South of England. It was also the pre-war home of Exeter Flying Club, but it was soon earmarked by the Air Ministry to become an Elementary Flying Training School, at which civilian pupils could gain their wings flying Tiger Moths (above) before joining the RAF for basic training.

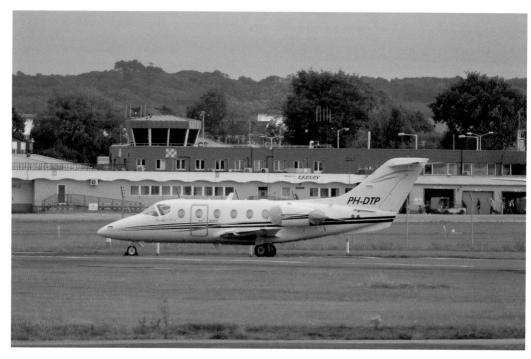

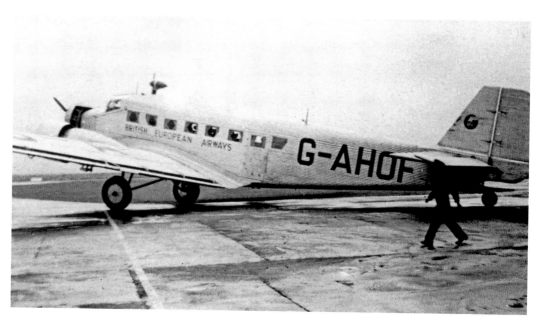

National Air Communications

At the outbreak of hostilities the airfield was taken over by a new Air Ministry department called National Air Communications, which used a variety of aircraft to ferry stores and personnel to the British Expeditionary Force in France. Their air armada included Handley Page HP42s and a number of Junkers 52 transport planes, purchased from Germany before the war by British European Airways (above). After the fall of France these aircraft became even busier, helping to evacuate the BEF, while after Dunkirk the NAC was discontinued as its tasking ceased to exist. Below, a modern airliner is seen at the airport today.

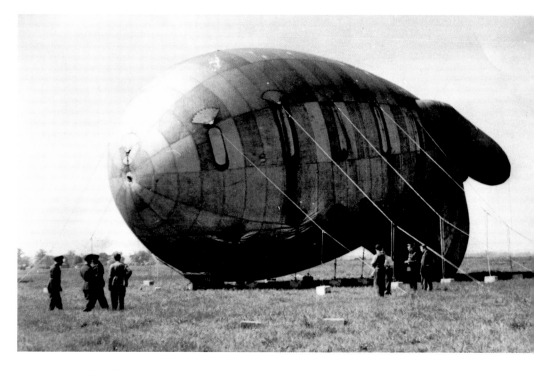

Guns and Balloons

Exeter was also used at this time by aircraft belonging to the Royal Aircraft Establishment to conduct experiments involving flying into barrage balloon cables in order to test devices designed to cut them. Aircraft used for this purpose included Fairey Battles and Vickers Wellingtons. These would fly to a special site on the Somerset coast at Pawlett to carry out these trials (above). June 1940 saw the formation of a Gunnery Research Unit at Exeter (below), who were employed to test the weapon systems of fighter aircraft, such as Supermarine Spitfires, Hawker Hurricanes and Boulton Paul Defiants.

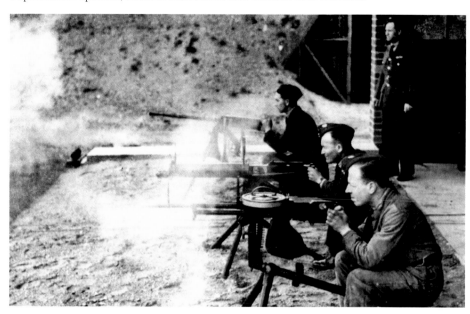

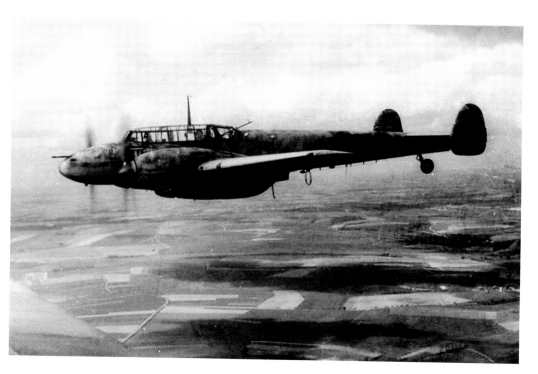

First Kill

On 8 July 1940 RAF Exeter was taken over by No. 10 Group Fighter Command and became one of the most important airfields in the West Country. During the Battle of Britain the station really came into its own, with Nos 87 and 213 Squadrons helping to repel countless attacks against the South and South West. The first enemy aircraft shot down by a Hurricane from Exeter was a Messerschmitt 110, like the one above, which had been taking part in a raid on Portland on 11 July. It was claimed by 87 Squadron. Below is one of the surviving wartime buildings of RAF Exeter.

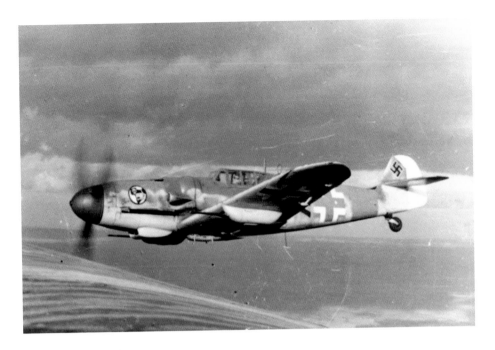

Height of the Battle

The peak of the battle as far as Exeter was concerned were three days beginning on Sunday 11 August 1940, when fourteen Hurricanes from the station were scrambled at eight minutes past ten in the morning to prevent another raid on Portland. With seventy bombers and ninety escorting fighters, this was the largest raid to be mounted on any target in Britain up until that point. In the resulting fight 87 Squadron shot down two Junkers Ju 88s and a Messerschmitt 109 (above), but unfortunately, both of Exeter's units lost two Hurricanes each. Below we see further wartime buildings at the site.

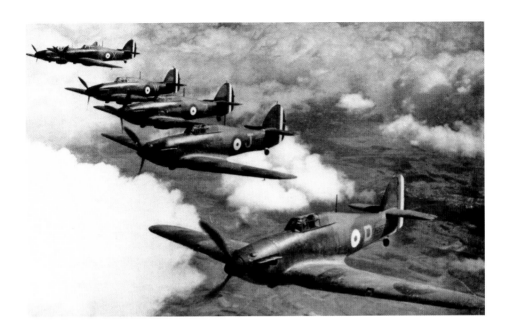

Adlertag

The next day 213 Squadron intercepted a large raid on Portsmouth, claiming a further brace of Ju 88s but losing another two of its own aircraft. The third day of heavy attacks, 13 August, was the long-awaited Adlertag, when Herman Goering, head of the Luftwaffe, had promised Hitler that his force would annihilate the RAF, enabling the invasion to begin. However, by the end of the day the Luftwaffe had lost another forty-seven aircraft, three of them claimed by Hurricanes from Exeter, and the battle was far from over. Above, Hurricanes go in for an attack, while below we see more of the surviving wartime complex.

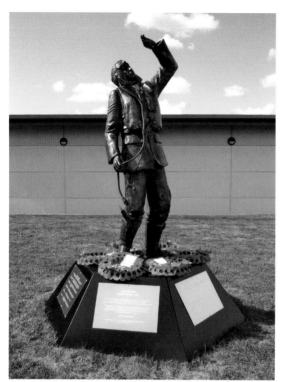

The Heaviest Day

For Fighter Command as a whole the heaviest single day of the battle proved to be 15 August 1940. This was also another sad day for RAF Exeter, which lost a further three pilots. On 27 March 2012 the memorial seen above was unveiled at the airport as a tribute to all those who served here. By the end of 1940 the battle was over, but RAF Exeter would continue to support many other important operations, one of the most significant being D-Day. The building seen below illustrates the fact that learning to fly from Exeter Airport is still a possibility today.

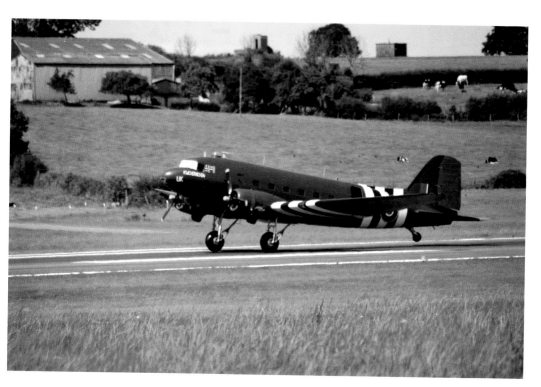

The D-Day Drop

The 440th Troop Carrier Group of the United States Army Air Force arrived in the spring of 1944. Their job was to transport American airborne troops into France at the start of the invasion. In the early hours of 6 June, forty-seven Douglas Dakota C-47s set off for the Cotentin Peninsula carrying paratroopers of the 101st Airborne Division. Once over their drop zones, the soldiers parachuted into the darkness to capture strategic positions behind enemy lines. Below, a paratrooper displays his equipment, while above, a Dakota in British invasion markings is seen at Exeter Airport in 2011. In the background are further reminders of its wartime infrastructure.

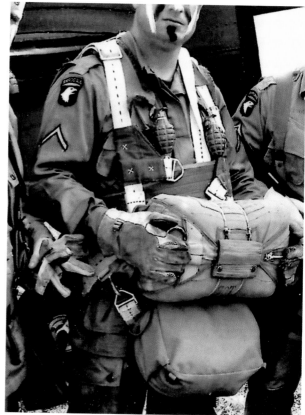

Resupply from Exeter

After D-Day, the 440th TCG flew regular missions to airstrips in France, carrying further troops and supplies, and to help evacuate battle casualties to American hospitals in England, such as Axminster (above). The Americans finally left Exeter in July 1944 and for the last few months of the war it ceased to be an operational station and became a Glider Training School, which helped to prepare a large number of glider pilots for the final push against the Japanese in the Far East. Below, a Spitfire (left) and Hurricane (right), war horses of the Battle of Britain, visit the airfield in May 2012.

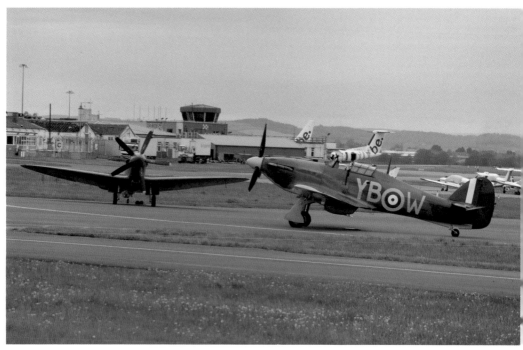

Building Hospitals

The Americans were responsible for building a number of hospitals in the West Country, which in the first instance would cater for the medical welfare of the troops stationed in the area and afterwards receive casualties from the battlefields of North Western Europe. The photograph above shows men of the X-ray department at the US hospital in Axminster, which was run by the 3rd Special Service Unit. The complex was mostly constructed of wood, although the Nissen hut seen below is now the last remaining original building on the site. After the war some of the wards were converted into council flats.

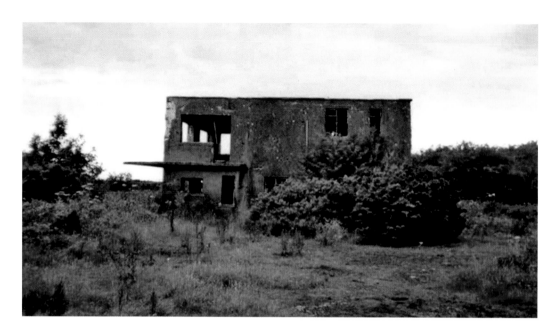

RAF Winkleigh

The remains of another Second World War airfield can be found near Winkleigh. It was intended for Coastal Command but, as the airfield was not completed until the end of 1942, it eventually opened as a Fighter Command station in January 1943. Later it was used by the United States 9th Army Air Force between October 1943 and February 1944. It was then taken over again by the RAF with various squadrons flying from here, including No. 161 Squadron, operating Lysanders on special duties. It ended the war as a Norwegian Air Force flying school. Above we see the watch office and below a memorial at the site.

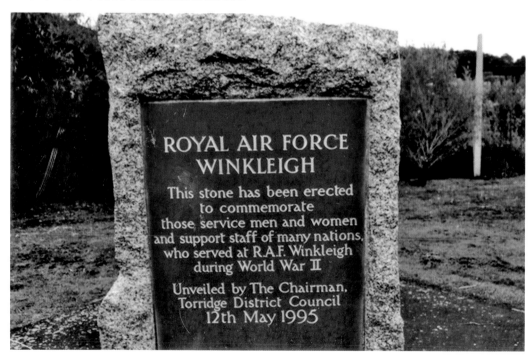

Secret Weapons

The Combined Operations Experimental Establishment was tasked with developing weapons that could be used to overcome German coastal defences. One project was to devise a way of breaking through the huge concrete walls that had been built along the French shore. One invention was the Giant Panjandrum, a huge wheel filled with explosives that would be released against Hitler's Atlantic fortifications. It was first tested on the beach at Westward Ho! seen above in the 1930s, but proved erratic and was never actually used in battle. The modern view of Westward Ho! below gives a good indication of why the area was ideally suited for this type of work.

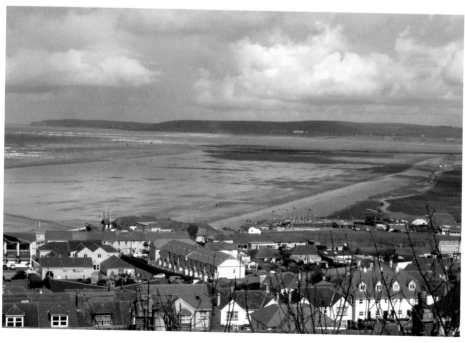

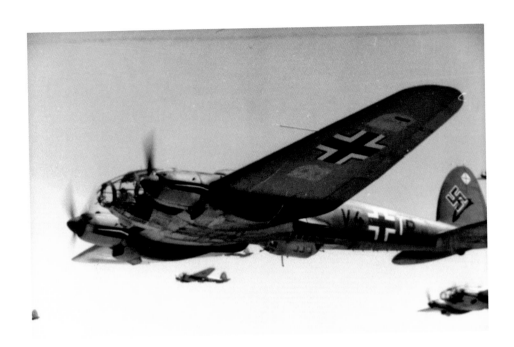

Devon's Furthest Corner

From Westward Ho! you can catch a glimpse of Devon's furthest corner, the remote island of Lundy, which you would imagine would have been passed over by the war, and to a large extent it was. However, in March 1941 a Heinkel He III similar to the example seen above crashed on the island after attacking a merchant ship in the Bristol Channel. The crew all survived and when they were taken to Appledore on their way to internment, a large crowd gathered on the quayside to shout abuse. Below we see Appledore Quay today.

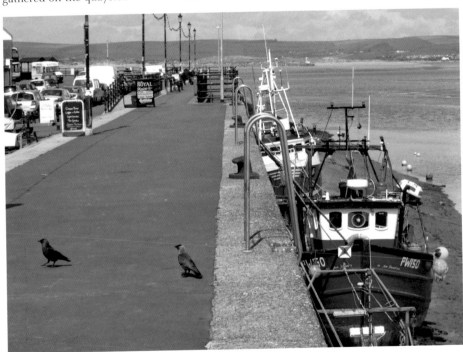

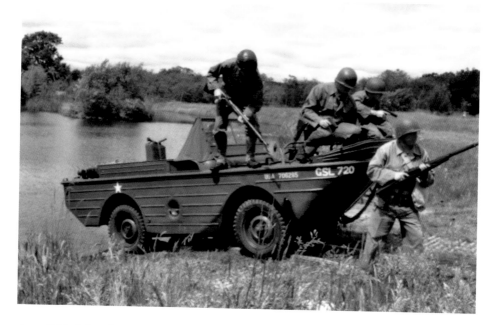

Assault Training Centre

The Americans were allocated the West Country to be near their embarkation points for D-Day, the planners of which understood it would be unlike any other battle that had taken place before. It was decided therefore to establish an Assault Training Centre or ATC in the area around Woolacombe, where the beaches had many similarities to those they would encounter in France, particularly Omaha Beach. Above, members of the 4th Division Living History Group disembark from a DUKW, an amphibious vehicle used during the invasion training at Woolacombe Sands, pictured below today.

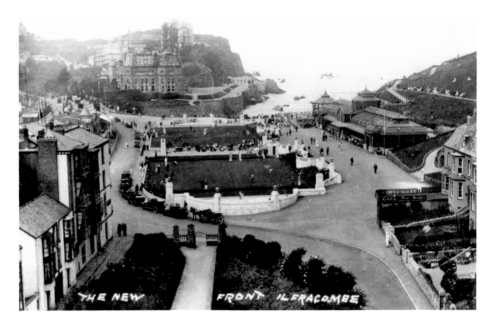

Invasion of Ilfracombe

Before the ATC could open, facilities for training and accommodation had to be put in place by American engineers. While this construction work was ongoing US personnel took over nearly every hotel and guest house in Ilfracombe; the Albermarle Hotel, for instance, was used as the glasshouse. Others were accommodated in Quanset huts, a larger version of the Nissen hut, which were erected in fields outside the town. Other premises commandeered included St James's church hall, used as a PX, while the Town Hall became the post office. Above, a pre-war view of the seafront and below, the harbour today.

Rail Traffic at Barnstaple

The GI studied in the photograph above is Corporal James Owens, who worked in the American Rail Transportation Office (RTO) at Barnstaple Junction, now Barnstaple Station as pictured below. It was taken in what is now the car park to B&Q, which in 1943 was the embankment leading to the station. The GI's job was to record the movement of all US Army goods traffic that went in and out of the many sidings that existed there at the time. With the thousands of American troops moving around North Devon, Barnstaple was a vital supply artery.

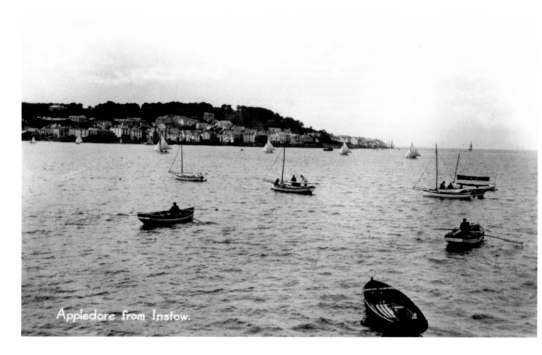

Appledore from Instow.

US Naval Bases

Bases were also established by the US Navy at Appledore, seen above from Instow in an old postcard, and Instow itself. These were mainly areas where various types of landing craft would be moored and prepared for the invasion. US Army personnel could also come here to acquaint themselves with landing craft and even learn a basic level of seamanship. Other landing craft and invasion vessels were also moored further up the River Torridge at Bideford, seen below in a contemporary photograph.

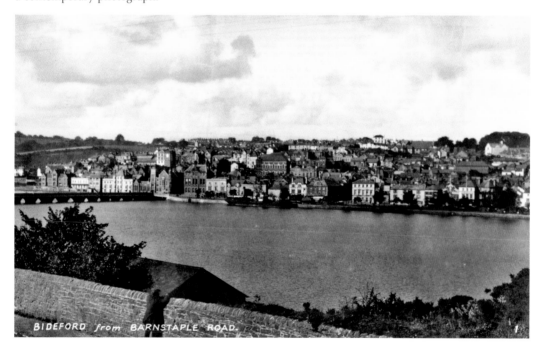

BIDEFORD from BARNSTAPLE ROAD.

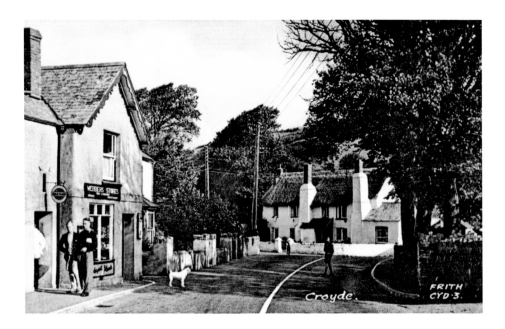

The Training Area

The ATC opened in September 1943, using the Woolacombe Bay Hotel for its headquarters (below). The training area didn't only cover Woolacombe beach itself, but took in a long stretch of coastline, including Saunton Sands and Braunton Burrows. Initially it had two purposes: to teach soldiers how to neutralise enemy beach defences, and then to train them to fight their way inland. Consideration was given to evacuating local villages such as Croyde, seen above in a contemporary postcard, but this idea was eventually shelved as American High Command found an alternative area for the latter task in South Devon.

Assault Tactics and Techniques

Troops for the ATC would arrive at Braunton railway station (above) and then be driven to a huge camp nearby. They would then undergo a three-to-four-week course in assault tactics and techniques. The area was divided into zones: Croyde Bay was used for loading and unloading troops with amphibious vehicles; Morte Point was an artillery target area; assault techniques were practised at Baggy Point, where US Ranger battalions would land on the beach and scale the cliffs; and full-scale landing exercises were held on Woolacombe beach itself. Below we see what remains of Braunton railway station today.

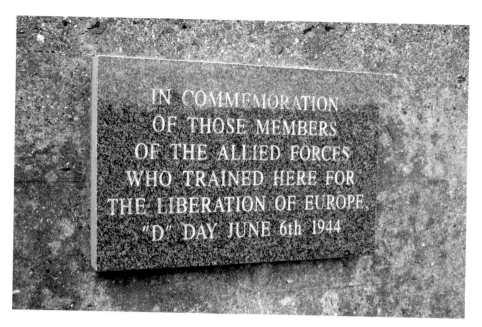

Training Aids

Concrete bunkers were built at Baggy Point to replicate those that had been constructed along the French coast, which teams of soldiers would train to attack and overcome. At Braunton Burrows a number of dummy landing craft were built in order to teach the men how to embark and disembark from them. Once proficient in these, they would progress to the more difficult task of using real boats in the surf. Engineers also laid out assault lanes on the beaches where troops would work their way through a series of obstacles. Above and below we see the remains of the dummy landing craft at Braunton Burrows.

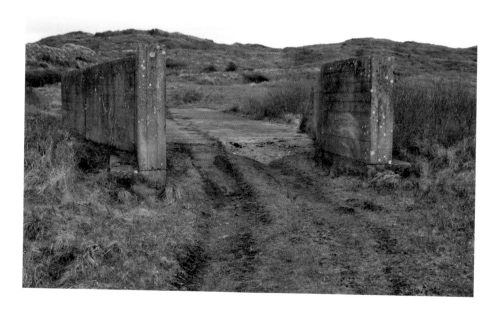

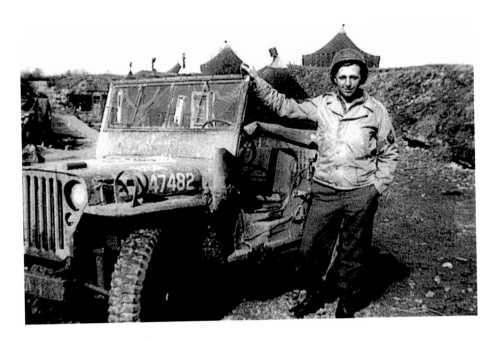

Disbandment of the ATC

The ATC was finally disbanded in May 1944 as by then the time for planning and practice was over. The memorial below, which can be seen on the seafront at Woolacombe, now commemorates the US forces who trained here in preparation for the Normandy landings. After D-Day, Lt-Col Paul Thompson, the brains behind the ATC, was of the opinion that if the Battle of Waterloo had been won on the playing fields of Eton, the beaches of Devon had certainly played an important part in winning the Battle for Normandy. Above is an American soldier with his jeep somewhere in the North Devon training area.

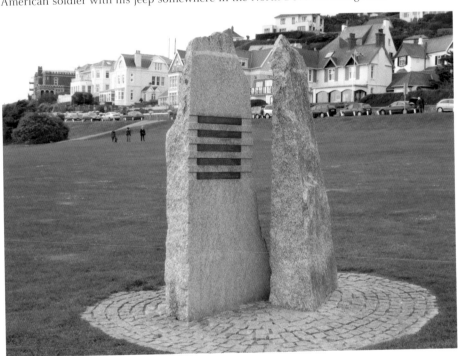

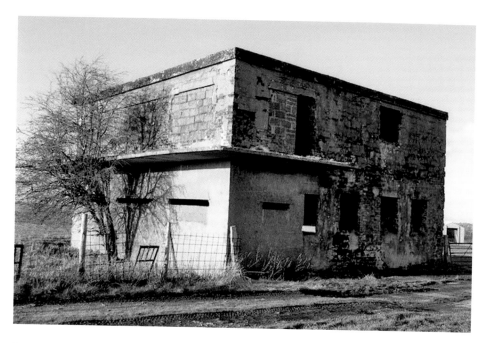

RAF Upottery

In 1943 another new airfield was built deep in the Blackdown Hills, near the village of Smeatharpe, known as RAF Upottery, which was also destined to play a crucial role during the invasion. On 26 April 1944 it was occupied by the 439th Troop Carrier Group, equipped with C-47 Douglas Dakota Skytrains and Waco gliders. During May, the group trained intensively in readiness for their part in D-Day. Above we see the old control tower today, while below a 40mm Bofors anti-aircraft gun owned by the South West Airfields Heritage Trust stands guard near the entrance to the airfield.

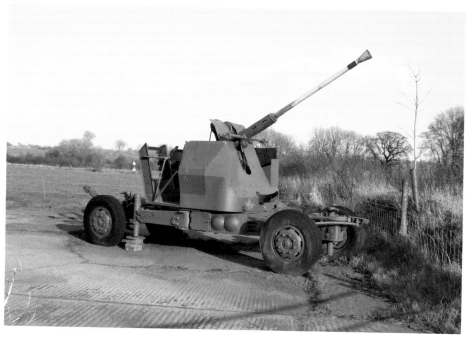

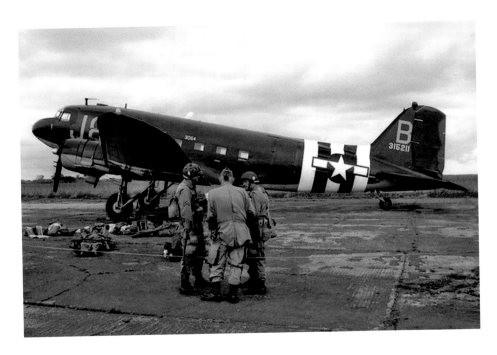

Band of Brothers

Just before midnight on 5 June 1944, around eighty C-47s took off from Upottery carrying over 1,300 men of the 506th Parachute Infantry Regiment. They were dropped in enemy territory behind Utah Beach. The drop also involved aircraft from Exeter and Merryfield aerodrome in Somerset. Among those who departed from Upottery were Easy Company, who were later portrayed in the book and television series *Band of Brothers*. Above, a C-47 in its original markings of the 439th TCG revisits the airfield during a fun day sixty-three years after it was based here, and below we see a surviving blast shelter.

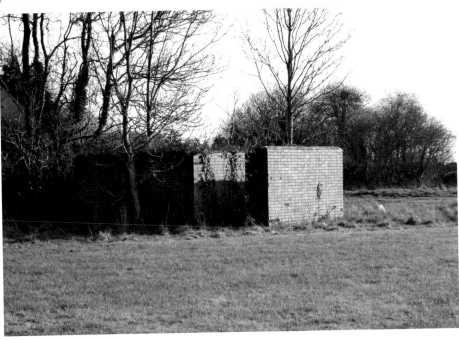

The Last Sentry

On 7 June 1944 the 439th were airborne again, this time transporting 968 men of the 325th Glider Infantry Regiment along with jeeps, supplies and other equipment. In the following weeks, similar to those from RAF Exeter, the Group's Dakotas were tasked with landing on grass airstrips newly opened in Normandy to ferry further supplies and evacuate battle casualties. Today the memorial shown above can be found at Moonhayes Cross on the Upottery to Churchingford Road, which was the site of the last sentry box to stand here. Below, we see one of the entrances to the airfield.

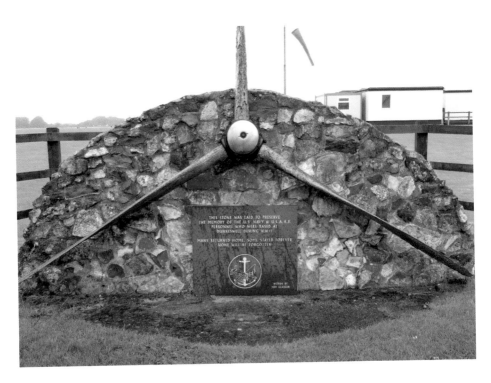

Hunting Submarines from Dunkeswell

A few miles to the west of Upottery was another Second World War airfield at Dunkeswell, which at one point was the only United States Naval Air Station in Britain. From here the Americans flew Liberators on anti-submarine patrols over the Bay of Biscay, hoping to catch German U-boats travelling to or from their pens along the French coast. Building began at Dunkeswell in 1941 and in May 1942 it was initially transferred to No. 19 Group RAF Coastal Command, who would themselves employ the base for anti-submarine patrols using imported Liberators. Above, a memorial at the site, and below we see the control tower today.

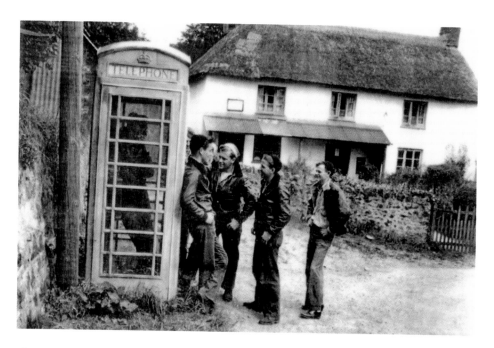

Fleet Air Wing Seven

In August 1943 Dunkeswell was handed over to 479 Anti-Submarine Group of the United States Army Air Force. When they left in December, the group had lost four Liberators and twenty-nine airmen killed in action. By this time all US anti-submarine duties had been handed over to the Navy's Fleet Air Wing Seven, and the station became known as the United States Naval Air Facility Dunkeswell. When operations ceased the Wing had flown 4,464 missions, sunk five submarines, and assisted in sinking four others, with the loss of 183 men. Above, US Navy personnel wait by the village phone box and below, the same scene today.

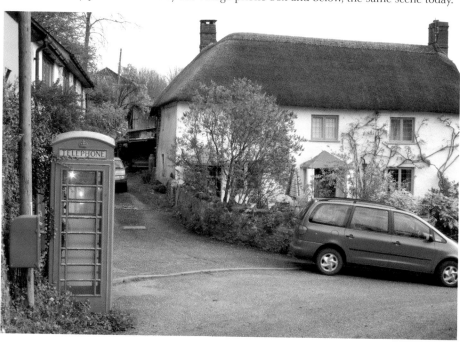

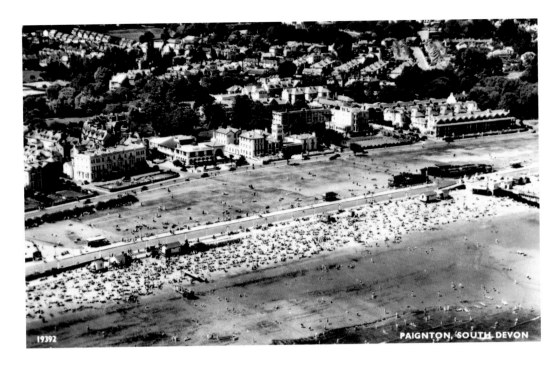

Holiday Camps

When the war began the government interned all aliens who fell into certain classifications. Some were sent to the Warners Holiday camps at either Paignton or Seaton. The camp at Paignton was for internees who were not regarded as a risk to national security and were therefore left unguarded. Those at Seaton on the other hand were subject to restrictions, so the camp was surrounded by barbed wire and had to be watched over. Above we see a view of Paignton in the 1930s, while the picture below shows the holiday camp at Seaton, which has since been demolished to make way for a new supermarket.

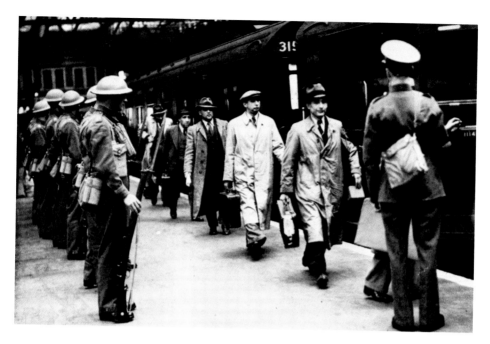

A State of Truce

At Seaton the government grouped together Jewish refugees with Germans who had fled Nazi Germany, German nationals already living here, and known fascists. Although at first this situation led to animosity and even some reported violence, it finally resulted in a state of truce between Jews and Nazis, and the internees lived a fairly peaceful life for the next few years. The photograph above shows internees being marched onto a train; their final destination would probably have been one of the Devon camps. The picture below shows the supermarket that today occupies the site of what was the Seaton camp.

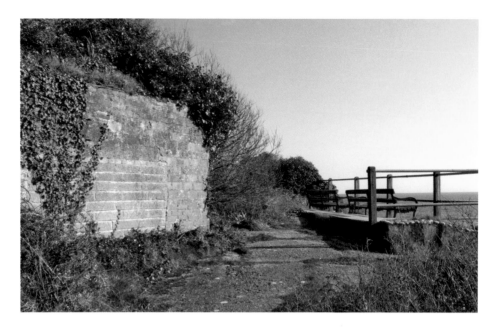

Stop Lines

In the summer of 1940, with Britain fearing an invasion, a series of stop lines were built around the country that would hold the Germans back should they land. These were largely made up of pillboxes. It was believed that Lyme Bay would be a possible landing-point for an invasion force and one line of defences ran from the Somerset coast at Pawlett down to Axmouth. This was known as the Taunton Stop Line and the gun position in the photograph above, overlooking Lyme Bay at the mouth of the River Axe, was the starting point of the line. Below we see another of the stop line's pillboxes near Axmouth.

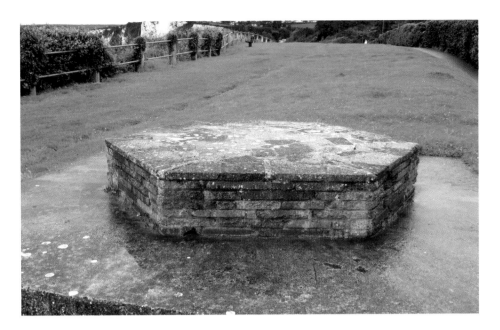

Coastal Defences

Seaton is a good place to see some of the remains of coastal defences that were established at the time of the threatened invasion. The hexagonal plinth above marks the place where an emergency Royal Artillery coastal battery stood. At the time it was camouflaged by a wooden construction to make it look like a house on the cliff-top. The photograph below shows the remains of a coastal artillery searchlight emplacement, which housed a very powerful lamp that swept the sea on the lookout for invading forces.

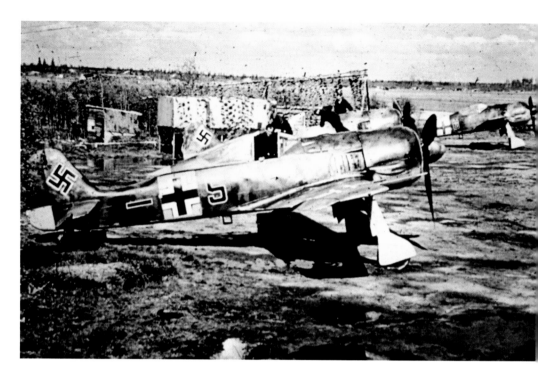

Tip-and-Run Raids

After their failure in the Battle of Britain, one of the Luftwaffe's tactics was to carry out what became known as tip-and-run raids in which aircraft flying fast and low would cross the coast without being detected by radar and therefore without warning to the general public. They would then drop bombs and machine-gun targets indiscriminately before beating a hasty retreat. During this time every town on the South Devon coast lived in perpetual fear of these sudden attacks. Above, Focke-Wulf FW190 fighter bombers prepare for a raid, and below, a contemporary postcard of Exmouth, which was attacked several times.

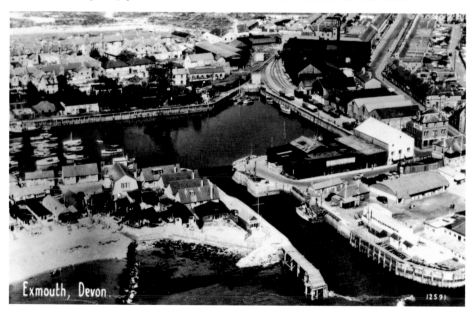

Exmouth, Devon.

12591

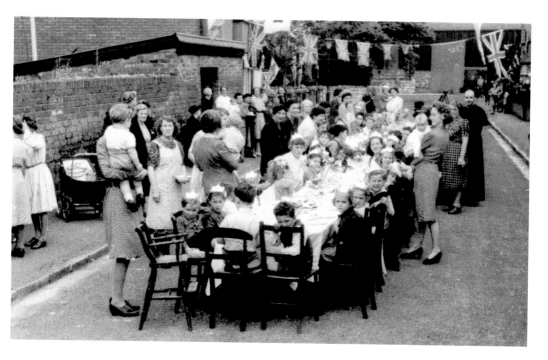

Attack on Exmouth

One such raid hit Exmouth on 26 February 1943. During this attack a 500kg bomb underwent a remarkable journey. It went straight through the middle of a three-storey building in The Strand without exploding. It then bounced across the street, passed through another shop and eventually entered the premises of a store called Hancock's, where it finally exploded. Twenty-five people died in Exmouth that day. Above we see the residents of Point Terrace in Exmouth enjoying the much happier occasion of VE Day. Below, the same spot today.

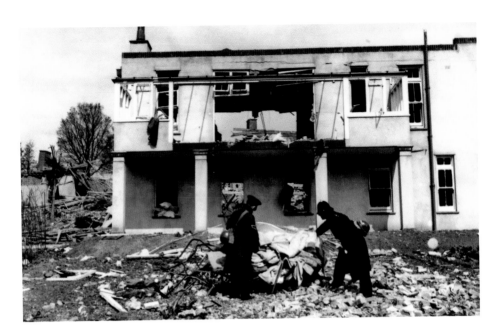

Teignmouth Targeted

A number of towns and villages along the South Devon coast experienced this type of raid, among the worst affected being Teignmouth, which was attacked twenty-one times, resulting in the deaths of seventy-nine people. On one occasion in May 1941 the hospital was bombed with three nurses and seven patients killed. As a coincidence, this hospital was rebuilt after the war and in September 1954 became the very first complete general hospital in England to be opened after the formation of the National Health Service. The photograph above shows some of the damage caused to the hospital by the raid, while below, Health Minister Iain Macleod opens the new hospital.

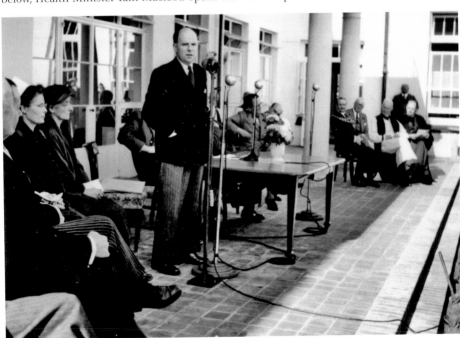

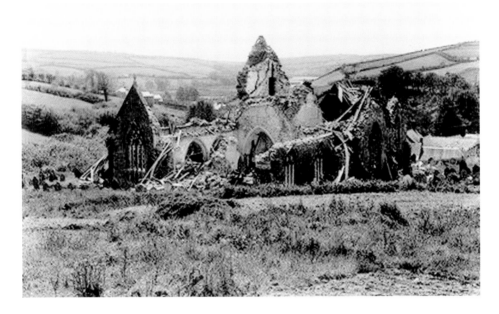

Bombing of a Rural Idyll

If any of these attacks illustrate how random they were, it must surely be the one that took place on the village of Aveton Gifford, a rural backwater which suddenly found itself under fire at around 4 p.m. on a January afternoon in 1943. Nearly every one of the 110 houses in this farming community was damaged to varying degrees. The only saving grace was that although twenty people were injured, the only fatality was a young girl. The church of St Andrews took a direct hit (above), destroying its thirteenth-century tower. It would be twenty-seven years before the tower was finally rebuilt (below).

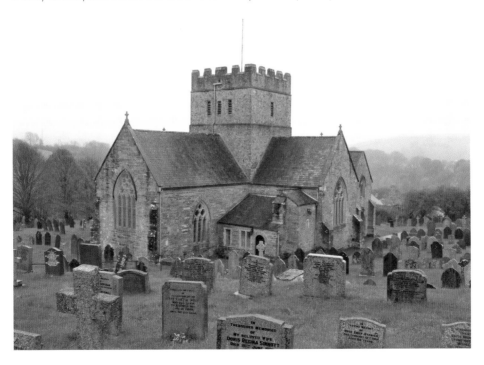

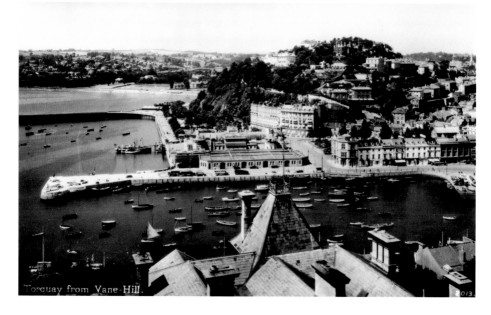

Torquay from Vane Hill.

Initial Training Wings

Torquay's main contribution to the war effort was for some of its hotels to be requisitioned for use by the RAF as Initial Training Wings. There were several of these ITWs established around the town, where students would be kitted out and receive basic training before being posted to Elementary Flying Training Schools for the next phase in their journey towards becoming aircrew. The Women's Auxiliary Air Force was trained at St Vincent's Hotel, which has since been converted into flats. Here some 8,000 young ladies were prepared for service. Above is a pre-war view of Torquay, while below, WAAFs undergo training.

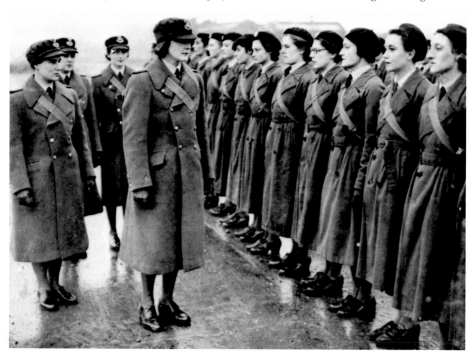

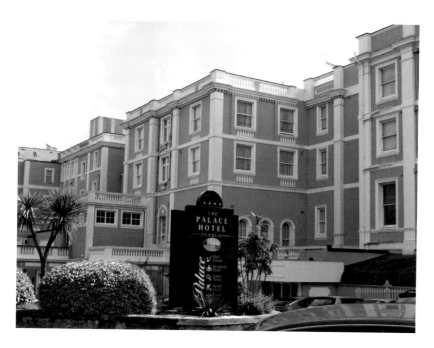

RAF Hospital Torquay

The Palace Hotel at Babbacombe (above) was used as a convalescent home for injured aircrew and became known as the RAF Hospital Torquay. Among those who spent time there recovering from injuries was Flight Lieutenant James Nicholson, Fighter Command's only Victoria Cross winner of the war. On 25 October 1942 the hospital was severely damaged during a raid which resulted in nineteen deaths. Another tragic event took place on Sunday 30 May 1943 when bombs destroyed the parish church of St Marychurch, where twenty-one children and three of their Sunday School teachers were killed. Their names are listed on the memorial below in Torquay cemetery.

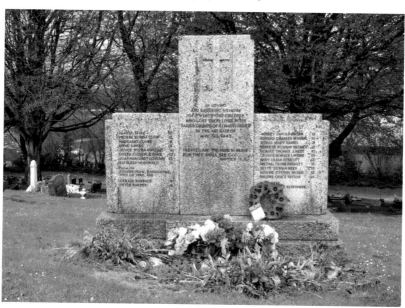

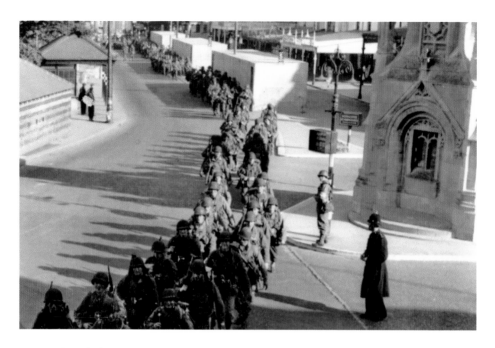

Torquay's Role in D-Day

Torquay's war, similar to most of the county, had two distinct phases. Early in 1944 the first US Army personnel arrived to establish the infrastructure needed for the town and harbour to receive and embark thousands of combat troops on the eve of D-Day. At first they were billeted in the homes of local people or guest houses until hotels became available as they were vacated by the ITWs. Torquay played a vital role in Operation *Overlord*, with more than 23,000 men of the US 4th Infantry Division departing from here bound for Utah Beach. Above we see men of the Division marching through Torquay towards their waiting craft, and below the same spot today.

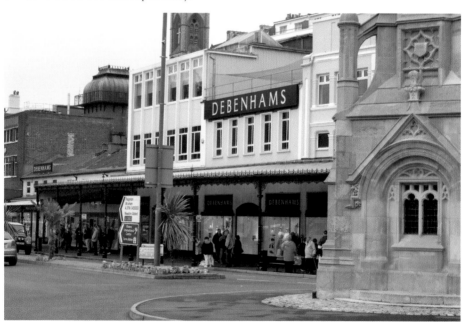

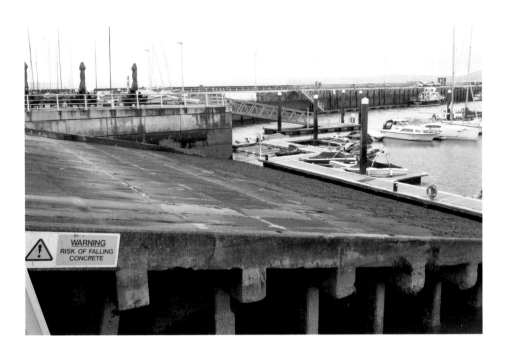

D-Day Hards

In preparation for D-Day, sixty-eight concrete ramps, or 'hards' as they were known, were built at various harbours along the South Coast from Falmouth to Felixstowe, from which the landing craft would be loaded with men and vehicles. These included two ramps at Beacon Quay, Torquay, one of which can be seen in the photograph above. These are now fenced off, although nearby you can see the memorial pictured below, erected in memory of both those who both built them and those who set sail from here in June 1940, heading for the coast of Normandy.

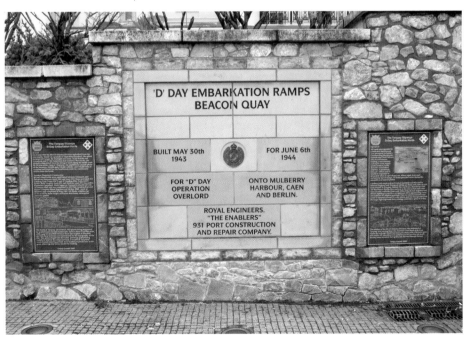

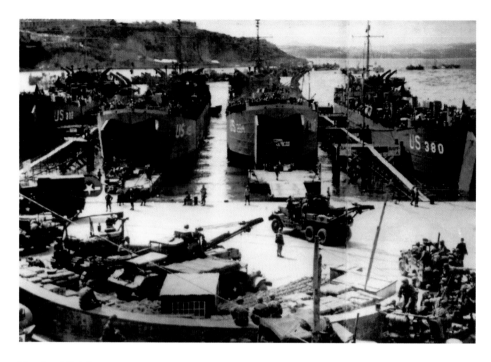

Hards at Brixham

Another of the D-Day hards can still be seen at the fishing port of Brixham, from where tanks and other heavy vehicles were also embarked. Above we can see landing craft being loaded at the slipway, with the same scene reproduced below as it appears today. A plaque at the site reads, 'This slipway was constructed for the embarkation of troops and equipment of the 4th Infantry Division of the VII Corps of the United States 1st Army upon their departure from this harbour for the D-Day landings on the beaches of Normandy. Tuesday 6 June 1944.'

Inner Harbour, Brixham BXM.23

The Belgian Fishermen

Earlier in the war, Brixham hosted a group of unusual refugees: Belgian fishermen who sailed into the Devon harbour at the time of Dunkirk to escape the Nazis. On arrival these Belgians were ordered to sail their boats to Dartmouth, where immigration officers would investigate the possibility that German spies had attempted to infiltrate the country among them. In time, many of these were allowed back to Brixham and for the rest of the war these men carried on fishing along the South Coast, securing a vital food resource for the nation. Above and below we see contemporary and modern views of Brixham's harbour.

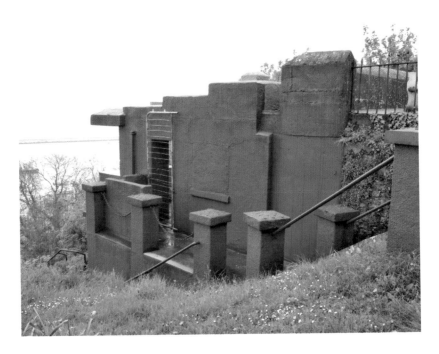

Protecting Torbay's Beaches

At Brixham there are the remains of coastal gun emplacements in Battery Gardens. This was the home of 362 Battery, Royal Artillery, later renumbered as 378 Battery. At first it was manned by regular troops but after the invasion threat had receded it was taken over by men of the 10th Battalion Torbay Home Guard. It was equipped with 4.7-inch guns for coastal defence and a Bofors gun for air attacks. Today there is a small museum situated in the old training room, run by enthusiasts of the Brixham Battery Heritage Centre Group. Above is the Battery Observation Post, and below a 4.7-inch gun emplacement.

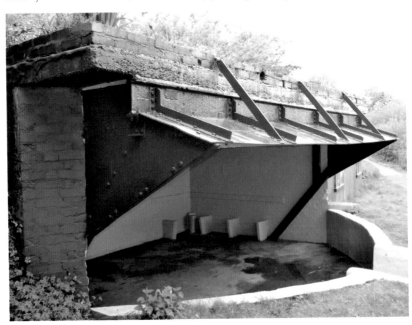

Tragedy at Corbyn's Head

During the war, the shelter pictured above was boarded up and used by the personnel at Brixham Battery as a guard house and store for small arms and spare parts. It was named by one of the compliment 'The Altmark', a name by which it is still known today. There was another 4.7-inch gun at Corbyn's Head, Torquay, manned by members of the 10th Battalion Torbay Home Guard. On the night of 11 August 1944, during training, the breech of the gun exploded, killing five members of the battalion and one Royal Artilleryman. The memorial below, which is dedicated to all members of the Home Guard, now stands on the site of the tragedy.

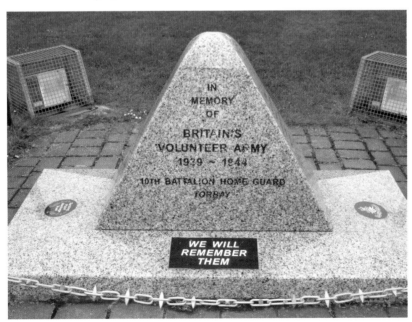

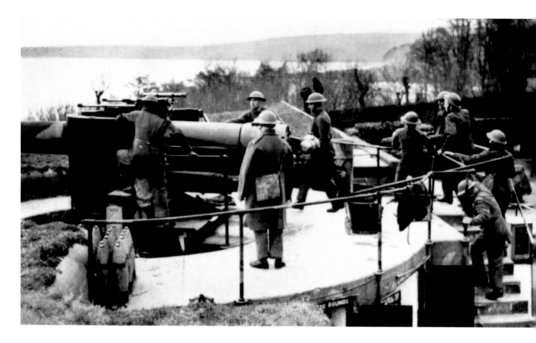

Brownstone Battery

Another of the emergency coastal defence batteries built in 1940 can be found near the mouth of the River Dart at Inner Froward Point. Brownstone Battery had a commanding view across Start Bay, where during the spring of 1944 its crew would have watched the US amphibious exercises at Slapton Sands. The battery was equipped with two 6-inch guns (above) taken from a First World War battleship, with each gun having a range of over 14 miles. These operated in tandem with a powerful searchlight situated close to the high-water mark. Below are the remains of one of the emplacements.

Varied Remains

Brownstone Battery was manned by approximately 230 soldiers of the 52nd Bedfordshire Yeomanry between 1940 and 1942. Once the threat of invasion had subsided, the site was manned by the Home Guard until the end of the war. As well as the two gun emplacements and the searchlight positions, one of which can be seen below, the site consisted of a variety of other buildings, including an observation post, generator room, ammunition store, accommodation block, latrines, general store and mess rooms. There was even a miniature railway to take the shells up and down the steep slopes. Above, soldiers can be seen loading a 6-inch gun.

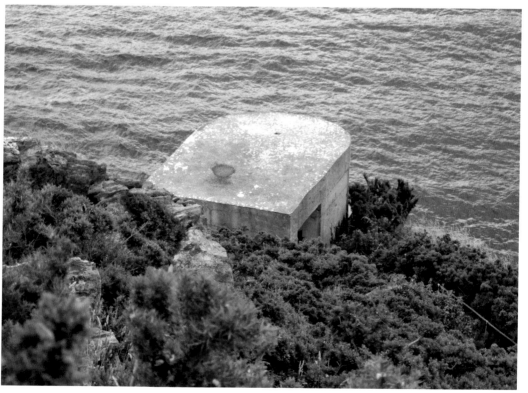

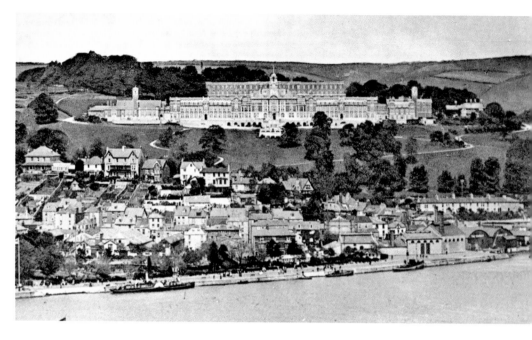

HMS *Britannia*

Another location in South Devon heavily associated with the Royal Navy is Dartmouth, the home of HMS *Britannia*, the Royal Naval College, pictured above in an old postcard and below, today. Although officer cadets have been trained in the area since 1863, the present college buildings were completed in 1905. They were struck by bombs during an air raid on 18 September 1942. At the time the naval cadets themselves were away on leave, but as a result of this raid it was decided to move the students to a safer location, which in the end turned out to be Eaton Hall in Cheshire.

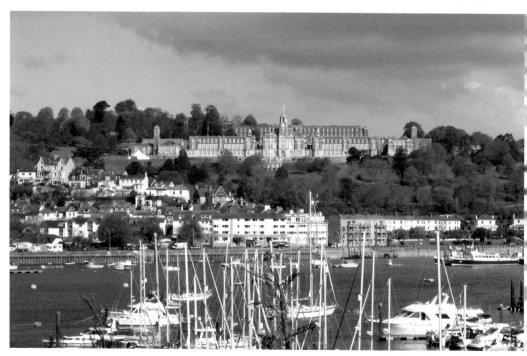

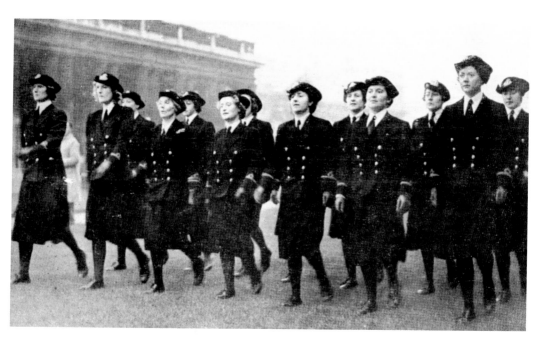

Wrens

After the students were moved from HMS *Britannia*, around 700 members of the Women's Royal Naval Service, or 'Wrens' as they were known, were accommodated at the college as well as using other large houses in the area. This was ironic as a Wren had been the only fatality at the college during the raid. During the same attack, the Philip & Son shipyard on the River Dart at Noss was also bombed. The raid resulted in the deaths of twenty employees and brought the company's production of naval vessels to a standstill, which didn't resume until early 1943.

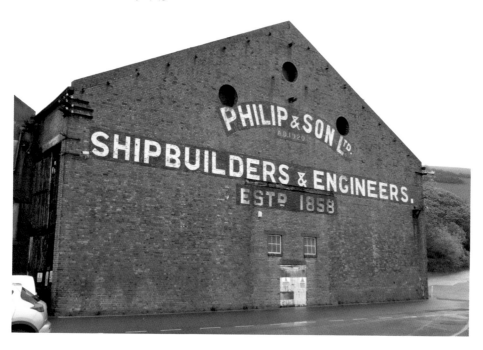

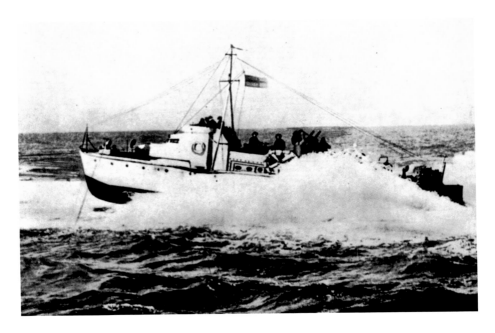

HMS *Cicala*

Dartmouth was bombed several more times and during a raid on 13 February 1943, the seventeenth-century Butterwalk (below), another of the town's famous landmarks, was seriously damaged. A number of people died in this raid in houses that collapsed nearby. On the opposite side of the river, at Kingswear, the Royal Dart Hotel was requisitioned by the Royal Navy and used as the headquarters of various groups of small boats that operated out of the Dart, including Motor Torpedo Boats like the one above. For this purpose it was given the title HMS *Cicala*.

Clandestine Operations

A number of flotillas were commanded from HMS *Cicala*, among them the 23rd MTB, comprising members of the Free French Navy. Much of their work involved clandestine operations with the French Resistance, smuggling secret agents, arms and equipment into France. They also picked up Allied servicemen who had escaped or evaded capture. Among the French personnel stationed here was Sub-Lieutenant Phillippe de Gaulle, son of the future president, and Lieutenant Francois Mitterand, who would one day become president himself. Above we see a wireless operator at work on board an MTB, and below the Royal Dart Hotel today.

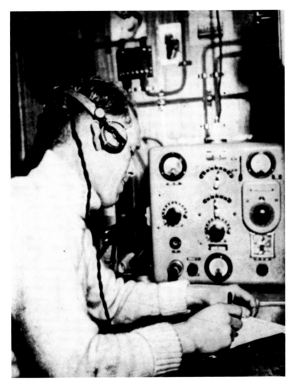

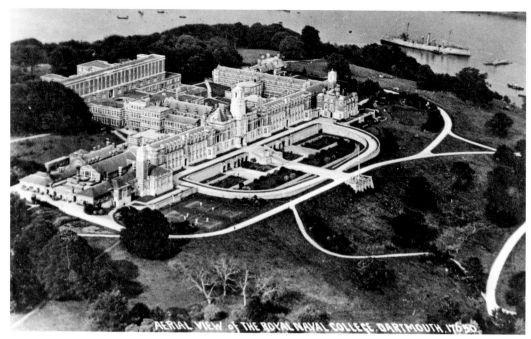

AERIAL VIEW of THE ROYAL NAVAL COLLEGE DARTMOUTH .1760.

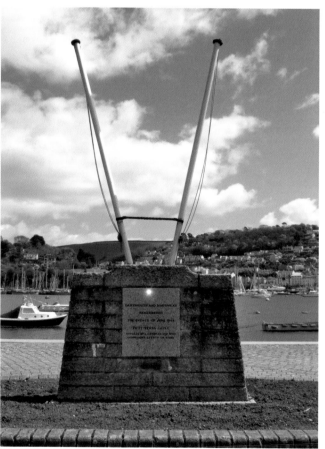

Along the Dart

In the build-up to D-Day the Americans assembled over 400 landing craft in the Dart, as well as other ships associated with Operation *Overlord.* Hutted workshops were built in Coronation Park as a facility to repair landing craft, and HMS *Britannia* became a US Navy school for amphibious training and gun support. The postcard above shows another pre-war view of *Britannia* towering over the river. And of course, on the eve of D-Day, Dartmouth was one of the ports from which the invasion force set sail for the Normandy beaches, as commemorated by the memorial below, found along the riverbank.

RAF Bolt Head

In December 1941 the RAF opened another fighter airfield near Salcombe, RAF Bolt Head, which became associated with tragedy. Before the United States entered the war, many young Americans volunteered to join the RAF and fight the Nazis. Some of these filled the ranks of No. 133 Eagle Squadron (above). In September 1942 this unit flew out of Bolt Head in Spitfire Mk IXs. Their job, together with two Canadian squadrons, was to provide fighter cover for American B-17 Flying Fortresses sent to bomb the Focke-Wulf works at Morlaix and the U-boat pens at Brest. Below we see the base of a picket post at the entrance to the airfield.

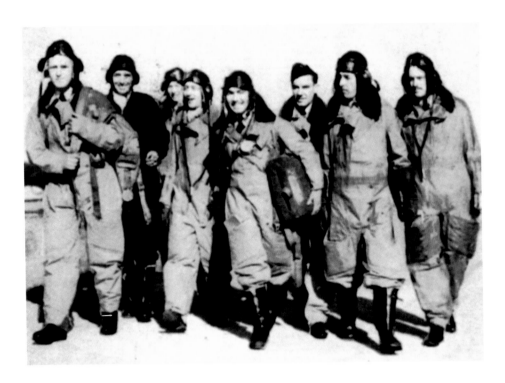

Loss of a Squadron

At the briefing before the mission, the pilots were given the wrong weather information. Consequently, when the fighters reached the rendezvous point they missed the bombers by twenty minutes. They decided to abandon the mission and return to Bolt Head. Eventually they began to make their descent towards what they thought was the coast of Devon, but was in fact the Brittany Peninsula. They were met by anti-aircraft fire and swarms of enemy fighters. The Eagle squadron lost all twelve of its Spitfires, with five of the Americans killed and seven taken prisoner. Below, a wartime structure at the site.

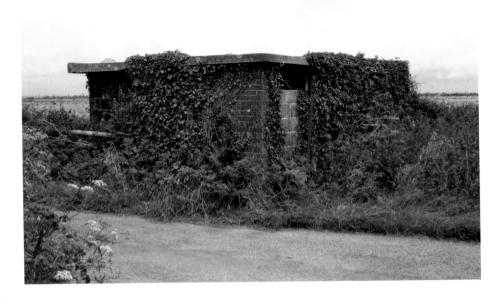

Slapton Battle Training Area

Towards the end of the war a large area was requisitioned in South Devon where full-scale rehearsals for D-Day could be carried out. This was the Slapton Battle Training Area, centred on Slapton Sands (above). Training began in August 1943, which would not only involve landing troops but would include battle scenarios requiring them to fight their way off the beachhead and into the hinterland. Because live ammunition was used during this training, the local residents were evacuated. Below is a monument at Slapton Sands constructed by the US Army, which catalogues the communities that were affected.

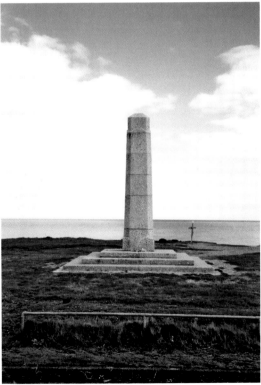

93

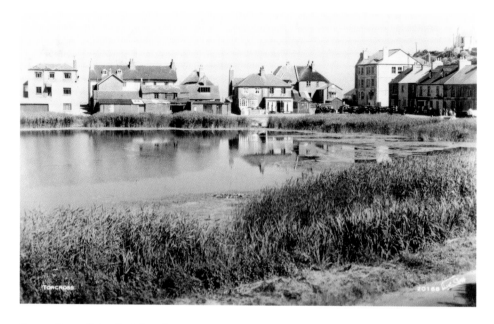

Evacuation of the Training Area

A total of 3,000 people, as well as their pets and livestock, were moved from the Slapton Battle Training Area. Above we see the village of Torcross in the 1940s, with the same scene replicated below as it appears today. The other evacuated communities were Blackawton, Chillington, East Allington, Sherford, Slapton, Stokenham, and Strete, together with many outlying farms and houses. In spite of a number of successful rehearsals for D-Day, this coastline became synonymous with a tragedy known as Exercise Tiger.

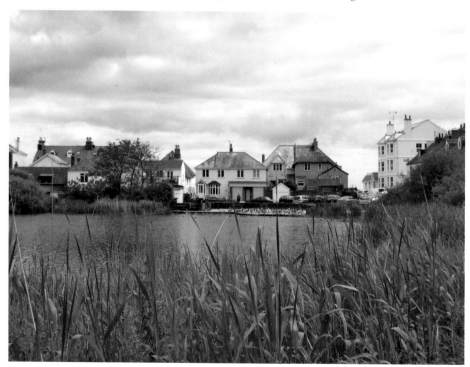

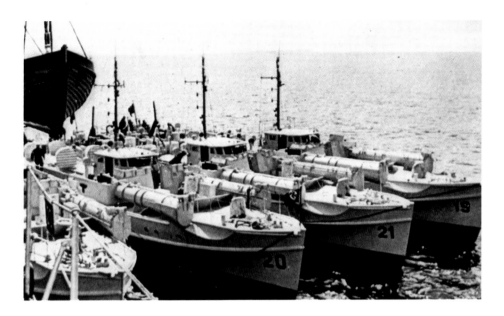

Exercise Tiger

On 27 April 1944 men of the US 4th Infantry Division stormed ashore and consolidated the beachhead. Early the following morning a flotilla of LSTs set out from various ports including Plymouth, transporting a follow-up force. Out of the darkness nine German E-boats appeared and launched a devastating attack. Two landing craft were sunk, with others damaged, and 749 servicemen were killed, more than the total who would perish on Utah Beach. Ten officers knew the locations for D-Day, which could have compromised the invasion if they were captured. As a result, it was nearly called off until all ten bodies were accounted for. Below is the Exercise Tiger memorial at Torcross; above, German E-boats.

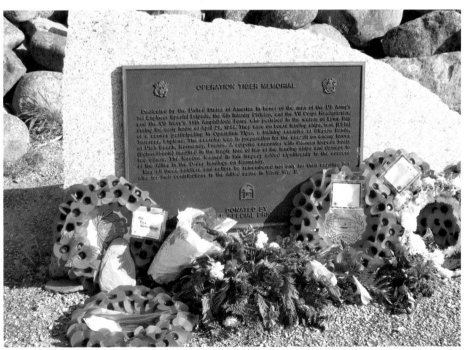

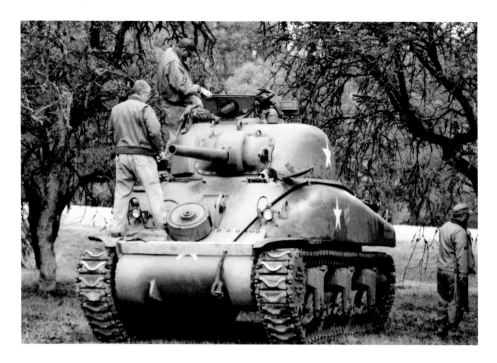

The Slapton Tank

In 1968 a gentleman called Ken Small arrived to run a guest house and began to wonder why there was no memorial for the servicemen who had died. He learned from local fishermen the whereabouts of a Sherman tank about a mile offshore. At considerable personal expense Mr Small salvaged the tank, which can now be seen in the car park at Torcross. It was dedicated as a memorial to the fallen in 1984. Today it is one of Devon's most poignant reminders of what took place throughout the county during the early months of 1944. Above we see a Sherman in working order, and below is the salvaged tank at Torcross.

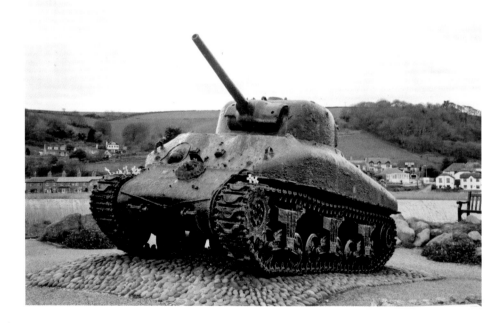